CENTRAL COAST
★★ AVIATORS ★★
............ *in*
WORLD WAR II

JIM GREGORY

*My best wishes,
Jim Gregory*

Published by The History Press
Charleston, SC
www.historypress.com

Copyright © 2018 by Jim Gregory
All rights reserved

First published 2018

Manufactured in the United States

ISBN 9781467139526

Library of Congress Control Number: 2017963920

Notice: The information in this book is true and complete to the best of our knowledge. It is offered without guarantee on the part of the author or The History Press. The author and The History Press disclaim all liability in connection with the use of this book.

All rights reserved. No part of this book may be reproduced or transmitted in any form whatsoever without prior written permission from the publisher except in the case of brief quotations embodied in critical articles and reviews.

CONTENTS

Acknowledgements	7
Prologue: Mission to Lorient	11
1. Pioneers of Flight	17
2. Learning to Fly: Air Cadets and WASPs	30
3. Bomber Crews: Bands of Brothers	43
4. This Seat of Mars	58
5. War in the Pacific	73
6. Losses	84
7. "For You, the War Is Over"	98
8. Strafing Runs	109
Epilogue: Nagasaki, Hickam Field	123
Notes	129
Index	139
About the Author	144

This book is dedicated to the memory of Tim O'Hara

*The son of Lieutenant Colonel Joseph O'Hara, U.S. Air Force
Eighth Air Force veteran, World War II*

ACKNOWLEDGEMENTS

I wrote this book for several reasons. I ran outside of my high school classroom once—in the middle of my European history lecture—and hopped up and down because a restored B-17 was flying over Arroyo Grande. I had recognized its engines from two miles away. I used to take my sons, when they were little, to the P-51 Mustang fly-in sponsored by the Santa Maria Museum of Flight, and I was the littlest boy of the three of us. I fell in love with the sound of the Mustang's powerful engine. It is glorious.

Most of all I wrote this book for the same reason I write all my books: I want people from a relatively rural part of California to understand what role their little towns, and sometimes their own neighbors, played in the great events of American history.

And of course, I wrote to record the memories of my father's and mother's generation, those people of immense personal strength who struggled through the Great Depression and then fought such palpable evil to win the costliest war in history.

Part of the strength of the Greatest Generation lay in their belief in what we once called "the greater good." It's ludicrous to think that they went to war willingly. They didn't. But they realized—and this is a theme I find over and over in my research—that it was time to interrupt their own lives, and they went to war despite their very human wants and their deepest fears. I often think that this sense of duty, of mutual responsibility—this selflessness—is something that we Americans would do well to revive.

Acknowledgements

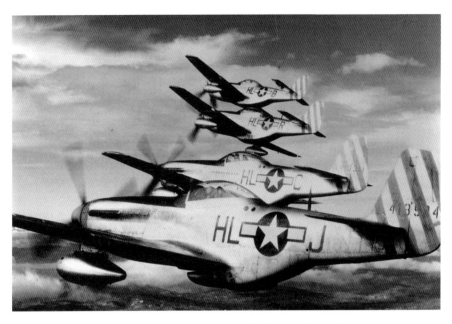

A P-51D formation. These planes carry the drop tanks that gave them the range to escort bombers deep into Germany, a turning point in the air war. *Museum of the United States Air Force.*

My research, including days when it took four hours to track down a B-24's serial number, started with the dead. Since the book's focus is primarily, if not exclusively, my home in San Luis Obispo County, I identified as many county aviation veterans (they were overwhelmingly U.S. Army Air Forces fliers, and of that group, the vast majority served in the European theater) as I could, based on the record of dead faithfully kept by the staff of the Atascadero War Memorial. I then spent many hours poring through old newspapers and visiting genealogy and cemetery websites and veterans' organizations to find out as much as I could about these young men—and women, because the book includes three Women's Air Service Pilots (WASPs). The real find—a kind of historical gold mine—was the collection of veterans' interviews patiently and skillfully conducted by Joanne Cargill and Joy Becker of the Central Coast Veterans' Muscum. It was those interviews that make up the backbone of this book. While it would be impossible for me to profile every local airman who served in World War II, it was these interviews that gave the book its focus. They are a treasure.

So is the Central Coast Veterans' Museum, in the basement of the Veterans' Memorial Building on Grand Avenue in San Luis Obispo, with its stunning

Acknowledgements

array of artifacts, uniforms and photographs from World War I through Desert Storm. The veterans who serve as docents are welcoming and informative. Curator Harry Hoover and archivist/secretary Sandra MacGregor were indispensable in helping this book to come together. So was the curator of the Santa Maria Museum of Flight—also worth a visit—Mike Geddry Sr., a man I could talk history with all day. As usual, I need to thank Laura Sorvetti of Cal Poly's Special Collections and Archives and Eva Ulz and the research staff of the San Luis Obispo History Center. Many thanks also go to some new friends I met along the way: Jody Kelly, historian for the Ninety-First Bomb Group; Lucy Maxwell of the American Air Museum in Britain; the research staff of the Imperial War Museum, London; collector Chris Brassfield; the wonderful people at Boeker Street Trading Company, who preserve photography from San Luis Obispo County's past; and the staff of the *San Luis Obispo Tribune*, including a skilled historian, David Middlecamp, and a talented reporter, Carol Roberts. Thanks, as always, to my editors at The History Press, Laurie Krill and Abigail Fleming, for their encouragement and their suggestions.

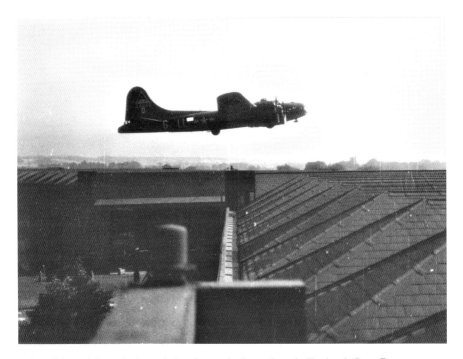

A B-17F, hopefully on its last mission, buzzes its home base in England. *Roger Freeman Collection FRE 3543 (Imperial War Museums).*

Acknowledgements

The best part of the research, of course, was meeting veterans and their families. My best wishes go to John Sim Stuart and family, the delightful Albert Lee Findley Jr., Henry J. Hall, the late Robert Potter Dwight, the descendants of Major Harold Schuchardt, Sylvia Barter, the Spierling family, Sybil Westerman, the late Richard Vane Jones's sister, Skip Eckermann, San Luis Obispo County Supervisor Bruce Gibson, the daughters of Robert Abbey Dickson and Sheila Reiff, the daughter of William Pope, and to all the veterans whose descendants I was able to contact for permission to use their interviews and who contributed additional material. It was an honor to work with you.

Also, I need to thank my wife, Elizabeth, for her patience while this book was being researched and written—in my usual manner, obsessively. Now, I think, it's time to bring my own imaginary Flying Fortress home.

Prologue

MISSION TO LORIENT

For a twenty-four-year-old B-17 copilot, death was close enough to represent a kind of eleventh man on his aircrew. For every American airman wounded in World War II, three were killed. The ratio was the inverse for foot soldiers, warriors whom the fliers both admired and pitied for what they had to endure in their agony, in lives of boredom, discomfort and terror, lives lived and lost in mud. Fliers, on the other hand, had farther to fall than a dogface in the hedgerows of Normandy or a marine on Red Beach at Iwo Jima. If they were like Morro Bay's Clair Abbott Tyler, a copilot in a heavy bombardment group based in England, they had five miles to fall.

On March 6, 1943, his B-17, piloted by First Lieutenant Martin E. Plocher, was flying in the third position, near the van of Tyler and Plocher's 360th Squadron, a component of the 303rd Bomb Group, based at RAF Molesworth in Cambridgeshire, a place where The New York Pizzeria today completes the Americanization of this little part of East Anglia, a process that had begun with the arrival of aircrews like Tyler's in September 1942.

Second Lieutenant Tyler was becoming a veteran. He had been with his squadron for a month, had flown three missions with Plocher's crew, and this was his squadron's twentieth mission over German-occupied Europe. This mission, on March 6, 1943, was one very early in the American air war against Nazi Germany, and in a very real sense, Tyler and the men and boys (many enlisted men on a B-17 were eighteen years old; Tyler, about to turn twenty-five in April, might then be referred to as "Pop") were pioneers

Prologue

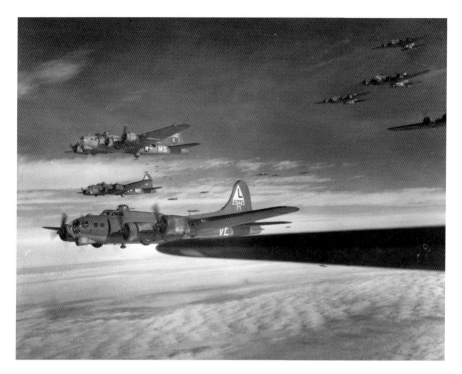

B-17Gs from the 381st Bomb Group. *Museum of the United States Air Force.*

intended to demonstrate the effectiveness of strategic bombing and to validate the name of their aircraft, the "Flying Fortress."

Pilots like Plocher and copilots like Tyler flew their Fortresses in compact box formations. On this mission, nineteen B-17s from their 360th Squadron assembled in the skies over England, assumed their box formations—seven in the lead flight, two boxes of six each following—flying virtually wingtip to wingtip to maximize the defensive power of thirteen .50-caliber machine guns on each ship.

If the formation was kept tight, the theory went, the "Flying Fortress" was impregnable. The most vulnerable, like weakened animals in a herd, were planes with mechanical problems or combat damage. They would fall behind, to be picked off by opportunistic German Messerschmitts or Focke-Wulfs, unless "little friends," American fighters like the twin-boomed P-38 Lightnings, arrived to shepherd crippled aircraft back safely to their English bases.

Mission 20, on March 6, 1943, was a rare exception to the usually dirty British weather, which made the beginnings of missions so dangerous—there

Prologue

were sometimes collisions between B-17s when squadrons ascended in fog or dense clouds. Each crewman would be on the lookout for neighboring bombers, unconsciously holding his breath until his ship reached the assembly point above the clouds. But this day, the skies were blue—in Plocher's memory, they were cloudless. It had to be a good omen for what would be, when compared to missions later in the war, a relatively short seven-hour round trip. The target, revealed to the 360^{th}'s fliers after their predawn breakfast, was to be a power plant and a bridge near Lorient, a port city beneath the arm of Brittany. Lorient was noted for, among other things, deep antiaircraft defenses and seemingly impenetrable concrete pens—they are still there today—that sheltered scores of U-boats as they prepared for their own missions, when they nosed needlelike into the North Atlantic.[1] It was the U-boats that waged the campaign to starve Britain of both supplies and of Americans, who were arriving in increasing numbers to prepare for the "Second Front" that would open more than a year later along the D-day beaches.

B-17s like Plocher's were a miraculous product of the American industrial expansion that was decisive in winning World War II. The Fortress was a remarkably resilient aircraft, one respected by American fliers, and the scores of photographs the war has left behind of B-17s that somehow returned to England with shattered tails, holed wings, smashed noses below the flight

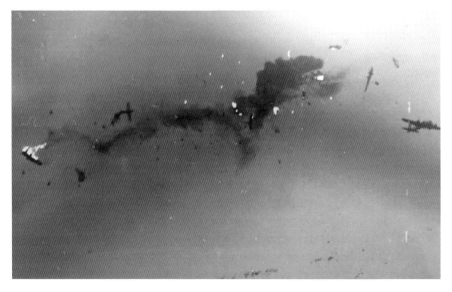

Two B-17s collide during the ascent to the assembly point over their English base. *Courtesy AAF veteran Bob Brown and the Central Coast Veterans' Museum.*

Prologue

deck, even of ships nearly shorn in half and held together by seemingly gossamer steel cables, are testament to that.

But in early 1943, they had a terrible weakness: there were not sufficient machine gun defenses forward—a deficiency later corrected with the B-17G's "chin turret," double .50-caliber guns below the Plexiglas nose. On March 6, 1943, that weakness would mean the sudden and violent end of Second Lieutenant Clair Abbott Tyler's life.

The squadron made its approach to the IP—Initial Point, where its bomb run would begin—unhindered by much groundfire, or flak, shells that were fused to explode at a prearranged height and send metal shards slicing through airframes and the men inside them, and in clear sky empty of German fighters. But the fighters suddenly appeared just before the homeward turn. They were Focke-Wulf 190s, among the finest fighters of the war, and they came out of the bright sun that day and pressed their attacks, as they'd learned to do, at the noses of the 360th's bombers. One of their targets was Martin Plocher's ship, suddenly staggered by 20-millimeter cannon rounds from a 190 that Plocher's crew had never seen coming.[2]

One of those cannon rounds shattered the copilot's seat and its occupant. Second Lieutenant Tyler was gone in a moment common to World War II

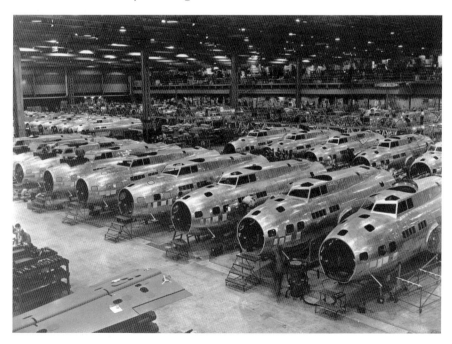

B-17 assembly at the Boeing plant, Seattle. *U.S. Air Force.*

combat: there was no transition between life and death, no time for a young man to collect his thoughts, no time to say goodbye in his waking dreams to the sights he would never see again.

If Tyler had been granted the chance to see again the sights of his life, one important landmark would have been the dome-shaped Morro Rock, prominent on the midpoint of the California coast, the "Gibraltar of the Pacific," and Clair would have seen it, either in its entirety or partly shrouded in sea fog, every day that he woke up as a child in his family's home on Piney Way in Morro Bay. But he would never again see his mother, who would, when he was a little boy, bundle him sleeping into the family car for trips to visit family in the Bay Area, to the magical place that was and is San Francisco. His mother made wonderful enchilada dinners, sometimes as fundraisers to help feed and clothe San Luis Obispo County children during the Great Depression. He would never again see his father, the man who took him bird hunting at the opening of pigeon season, the man who gravely instructed Clair on the maintenance and safe handling of a .410 shotgun.

There was no high school in Morro Bay then, so Clair went down Highway One to attend San Luis Obispo High School with friends he would never see again, like the best man at his wedding, Alex Madonna, part of the North County's heritage of Italian-Swiss dairy farmers, and of course, he would never again see his wife, Joanna Renetzky Tyler, part of the South County's *ranchero* heritage. The Renetzkys were related to the family of William Goodwin Dana, one of the earliest American settlers in this part of California and the owner of the vast Rancho Nipomo.

Finally, he would never again see his little girl. In March 1943, the month of the fatal mission to Lorient, she would just have begun walking. She would make the journey of her life without her father. Tyler's parents would likewise finish their life journeys without their son, their only child, and contemporary newspaper accounts suggest that they hoped, deep into the summer, that he had survived.[3]

But the German fighter had not only killed Tyler, it had dealt his ship a mortal wound as well. Both the Number One and Two engines were knocked out. Lieutenant Plocher, with the ghastly remains of his copilot in the seat next to him, fought to keep the bomber up, but when the Number Four engine overheated, there was no recourse, with the plane dropping rapidly, but to ditch at sea. Plocher, in a masterful piece of flying, brought it off. He and his crew would survive to be picked up by a German patrol boat, finishing out the war as POWs. But they survived.

Prologue

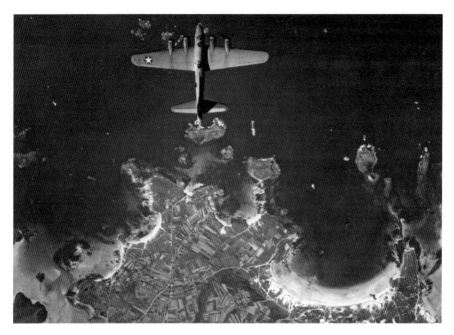

A lone bomber from Clair Abbott Tyler's 303rd Bomb Group, outward bound. *Museum of the U.S. Air Force.*

For Second Lieutenant Clair Abbott Tyler, who did not, and whose body disappeared when B17F #42-5626 slipped beneath the surface of the English Channel, there is a limestone memorial with his name and the names of other missing American soldiers at the American Cemetery in Brittany. There are at least seventeen other San Luis Obispo County aviators memorialized in cemeteries from Texas to Idaho, from Normandy to Italy, from Oahu to New Guinea. Others would survive the war to come home to their little girls, and they would live long lives as family men, as attorneys and high school teachers, as businessmen and mechanics, and when their journeys were finally completed, these men were remembered for their heroism. So, too, were the women who were their contemporaries, who flight-tested planes or ferried them from factories to air bases around the country. Some of them did not come home alive. But this is a story less about death and more about remarkable lives. This is a tribute, then, to young lives lived in combat, where the greatest enemy was not German or Japanese. The greatest enemy was fear.

1

PIONEERS OF FLIGHT

The Fourth of July 1910 was arguably not the most patriotic in the nearly sixty years since San Luis Obispo County and California had joined the Union. That distinction probably went to 1898's observance, coming, as it did, during the Spanish-American War and on the heels of a decisive American naval victory, on July 3, over an outclassed and archaic Spanish fleet commanded by Admiral Cervera off Santiago de Cuba. Cables announcing the latest American triumph over the "perfidious Spaniards," an image crafted by yellow journalists Joseph Pulitzer and William Randolph Hearst, had reached their New York papers and even those in San Luis Obispo. So it was, as the local *San Luis Obispo Telegram* noted, a "War Fourth," and one marked by "joyous enthusiasm" on the part of the celebrants in the county seat, which was approaching a population of three thousand.[4] But twelve years later, the city and the county were celebrating their Americanism in anticipation of a technological miracle: it would be an American invention, the airplane, that on July 4, 1910, would make its first appearance in history in the skies over San Luis Obispo.

In the seven years since the Wright brothers had made the first flight—of 120 feet—at Kitty Hawk, North Carolina, two San Francisco brothers, Lincoln and Hillery Beachey, were popularizing heavier-than-air flight up and down the Pacific coast. It would be the older brother, Hillery, who would fly the Beachey machine, modeled on a Glen Curtiss design, on this July 4, taking off from the baseball field south of town. Hillery Beachey was a balloonist who had all of seven months' experience flying airplanes.

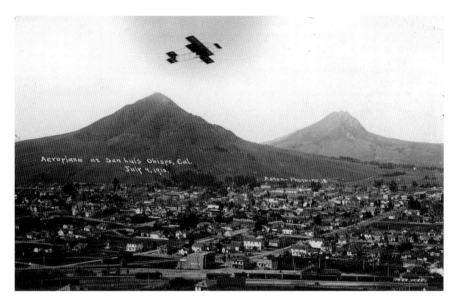

The first airplane flight over San Luis Obispo, July 4, 1910. *Courtesy of University Archives, Cal Poly State University, San Luis Obispo, Special Collections and Archives.*

He had evidently fallen under the sway of Lincoln, whose passion for flight had begun in boyhood, when he would launch his brakeless bicycle down Fillmore Hill, at the edge of Pacific Heights, to achieve brief airborne moments as he careened toward San Francisco Bay.[5] Like the Wright brothers, the Beachey brothers' engineering careers would begin with their opening a bicycle shop, and while Lincoln's fame as a stunt pilot would eclipse his elder brother's, on this July 4, all eyes in San Luis Obispo were focused on Hillery.

The airplane fascinated local residents. On display on Higuera Street three days before its exhibition flight, the "wonderful little machine" may have eclipsed the usual pre-fireworks highlight of the holiday, a nearby performance of military airs and popular tunes, including "Gems of Stephen Foster," by the county band. The band opened the festivities on the Fourth itself, followed by a parade led by the popular, barrel-shaped Irish American county sheriff, Yancey McFadden, still basking in the afterglow of his arrest of Willie Luis, notorious as the killer of his stepmother, Gon Ying, in the living quarters above the family's Ah Louis Store in San Luis Obispo. Wheelbarrow races for boys and a footrace for girls followed in the afternoon before Beachey's aircraft was wheeled out of its tent toward the baseball field.[6]

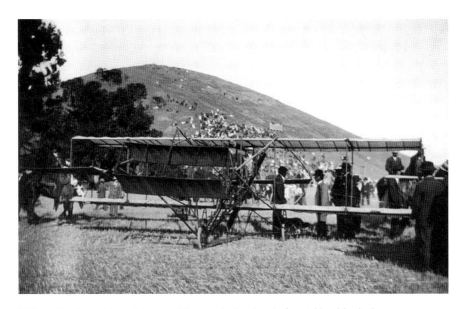

Hillery Beachey (*right center*) talks with an onlooker just before taking his airplane up over San Luis Obispo. *Courtesy of the Michael J. Semas Collection, Boeker Street Trading Company.*

A photograph captures, in a poignant way, the significance of this particular Fourth. Beachey, just before his ascent, is engaged in conversation with onlookers, while at the image's left edge, a cowboy—emblematic of the county's history as a "cow county"—dressed in his Sunday best, sits astride his horse, gazing uneasily toward the photographer. A crowd has collected on a hill in the background, waiting expectantly for the five o'clock launch of what was then called an "aeroplane," which resembles nothing so much as a tricycle undercarriage surmounted by box kites. The pilot's seat was well forward, as if it was intended that he would be first to make contact with the ground in a crash.

The crowd would be disappointed. Strong winds hampered Beachey, and the flight was so brief that local dignitaries paid Hillery only $500 instead of the agreed-upon $1,500 for a more satisfactory exhibition. It would be Lincoln, not his brother, who would demonstrate a flair for more dramatic exhibitions, executing death-defying loops, flying over Niagara Falls—collecting, along the way, a following of smitten young women, many of them gifted with diamond engagement rings—and surviving every crash except for the last one. In March 1915, while demonstrating a monoplane of his own design in his hometown, a crowd estimated at a quarter of a million watched in horror as the Beachey flyer's wings folded and the plane plummeted into

San Francisco Bay. While Hillery Beachey would live into old age, Lincoln, trapped in his airplane's wreckage, drowned in the bay he'd dreamed of flying over in his headlong bicycle rides down Fillmore Hill.⁷

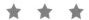

Harriet Quimby's image was her greatest asset and, in some ways, her greatest handicap. She was a beautiful woman, radiant when she smiled, and all that femininity clothed in her characteristic plum-colored flying suit prevented her, perhaps, from being recognized for the serious flier she was. It's not that Quimby was averse to publicity. She cultivated it, and she had what we would today call "media savvy," a skill she'd learned in male-dominated offices enshrouded in cigar smoke and furnished with brass spittoons. Before she'd taken up the challenge of flight, Quimby excelled at newspaper reporting.

In 1900, she was a reporter for the *San Francisco Bulletin*. By 1910, she was in New York, where she made the transition from reporter to participant while covering air meets along the East Coast. After a year of lessons, she became the first woman in America—and only the second in the world—to earn a pilot's license, an accomplishment made more remarkable by the example of her instructor, who had been killed in a flying accident.⁸ Harriet, who also drove—fast—was canny enough to persuade her employer, *Leslie's Illustrated Weekly*, to pay for her flying instruction, which she covered in a series of articles.

Quimby was, in fact, reinventing herself. She decided to make aviation her new career. In the process, she became creative with her own life story: she lost nearly a decade in age, claiming she'd been born in 1884, not the more likely 1875, and she moved her birthplace west—from Michigan to Arroyo Grande, California, where Quimby and her family evidently lived before she'd struck out on her own for San Francisco and journalism. She also cultivated a unique fashion sense: the plum-colored satin flying suit would become a fixture at airshows, which also generated income: she won $600 for winning an air race and $1,500 for taking up the challenge to become the first woman to fly at night, in a flight that lasted all of seven minutes.

Despite her glamour and her flair for self-promotion, Quimby was a skilled flier. She was insistent, after continuing to learn from more experienced pilots like Lincoln Beachey, on meticulous preflight checks and

Harriet Quimby. *Library of Congress.*

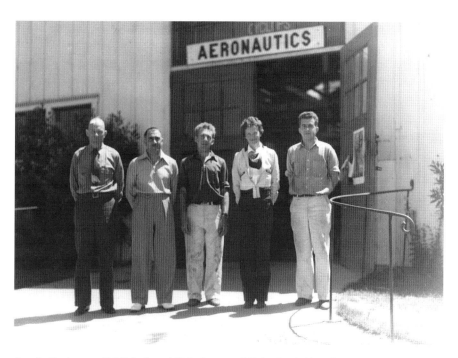

Amelia Earhart at Cal Poly, June 1936. *Courtesy of University Archives, Cal Poly State University, San Luis Obispo, Special Collections and Archives.*

insisted on wearing a seatbelt. Sadly, the event that would have made her an even bigger celebrity—becoming the first woman to fly across the English Channel—became buried in the back pages of American dailies because she accomplished the feat the day after *Titanic* foundered in the North Atlantic.

Quimby herself had only three months to live. Her death, like Lincoln Beachey's, came over water and in front of a horrified audience. On July 1, 1912, she was flying, with the organizer of a local air meet as her passenger, over Boston Harbor in a Bleriot monoplane. She flew an eventless outward leg to Boston Light, but on her return, at about one thousand feet, the Bleriot pitched, throwing out first the passenger and then, moments later, the pilot. Five thousand stunned onlookers witnessed Harriet Quimby's death as she fell into Boston Harbor.

Lincoln Beachey ungraciously opined that a burst of speed from the Bleriot and the rush of wind into Quimby's face had caused her to faint.[9] His own plunge into San Francisco Bay wouldn't give him enough time to revise that opinion. Flying was admittedly dangerous; the airplanes themselves, wood and fabric and wire, were perhaps far more delicate than fliers like Harriet Quimby. The danger wouldn't deter an admirer of hers. An Iowa girl, Amelia Earhart, was about to turn fifteen years old when headlines around the nation brought the news of Quimby's death.

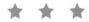

When Earhart flew into the little airstrip adjoining the Union Oil tank farm, grandly named Clark Field, in San Luis Obispo in June 1936, she remarked that she'd flown over the town many times and had always wanted to visit. On what was billed as an "inspection tour," Earhart's stop was arranged so that she could see the facilities at Cal Poly's aeronautical engineering department. She had evidently borrowed an airplane—her beloved Lockheed Vega, in which she'd flown from Hawaii to California the year before, was in storage in Burbank. Meanwhile, her next plane, the beautiful twin-engined Lockheed Electra, was still under construction. A year later, both the plane and the pilot, along with navigator Fred Noonan, would disappear in the South Pacific, leaving behind a heartbreaking and gradually fading string of radio messages monitored by the U.S. Coast Guard cutter *Itasca*, doing picket duty during Earhart's ill-fated attempt to fly around the world.

On this day, Earhart was impressed with the town of about eight thousand people. "I think you have a beautiful little city," she remarked to a local reporter. "It seems to be so closed in and comfortable-like." She was equally impressed with Poly's aeronautical engineering program, with one caveat: there were no women students enrolled. "A woman has as much right to study and make her way as a man," she said. She was pleased enough with her visit, she added, so that she wanted to come back "in a short time."[10] Had she lived long enough, she would have landed on a different airstrip, at a brand-new county airport in the Edna Valley that would open in 1939—today's McChesney Field.

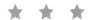

In the 1920s and 1930s, Leroy McChesney Jr. set out the family dairy's milk cans on a siding for the little narrow-gauge Pacific Coast Railway to carry north from the McChesney place, in Corbett Canyon, to the Golden State Creamery in San Luis Obispo. The family took a colorful and roundabout route to come to the county and their dairy farm: the senior Leroy McChesney, a merchant seaman and trade representative, had lived in Honolulu and in Yokohama, where he'd lost his first wife to illness. It was her best friend, Emma Patchett, who came to Japan to act as caretaker-governess to young Manson McChesney. Five years later, in 1905, Leroy Sr. and Emma married. They returned to America, and in 1919, the family—with the additions of two more little boys, Jess Milo and Leroy Jr.—made the precarious automobile trip along the Lincoln Highway from their home in New Jersey to the Patchett place in Corbett Canyon, where they established the Royal Oaks Dairy, added a daughter and finally set down roots.[11]

So Leroy Jr. and Jess Milo—tall, angular and thoughtful young men—would spend a good portion of their youth in milk barns. That didn't stop young Leroy from small rest stops during the hard workday typical of a dairy. When Leroy was outside, his gaze would turn skyward, where he stared transfixed at turkey vultures as they soared effortlessly on wind currents far above Corbett Canyon. The McChesneys were fascinated by flight. When, in March 1922, a puddle-jumping passenger plane mistakenly landed on neighbor Frank Costa's farm instead of its intended destination, Santa Maria, a photograph of the plane and its seemingly jovial passengers found its way into the McChesney family album.[12]

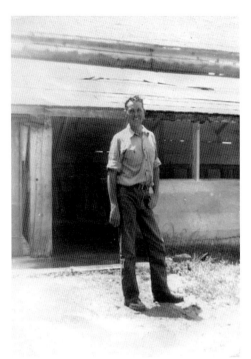

Left: Leroy McChesney Jr. at the family's dairy farm in Corbett Canyon. *Courtesy of Michael McChesney.*

Below: Mistaken landing in Corbett Canyon, 1922. *Courtesy of Michael McChesney.*

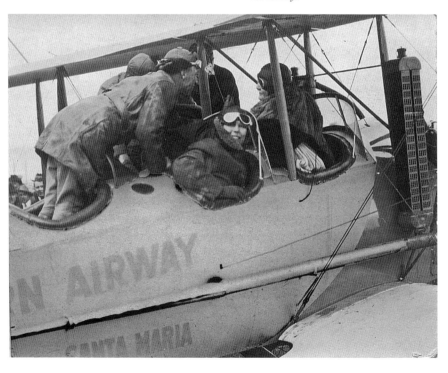

That may have been a decisive moment for the McChesney boys: Leroy would someday become a pilot, then an advocate for the county-owned San Luis Obispo Airport, then head of the California Aeronautics Board. His real passion for flying became obvious once he'd married and started a family with his wife, Grace: the family had to knock out a wall in the living room to make room for the glider Leroy was building there from a kit he'd bought. The children still remember ducking under the fuselage as they made their way from the living room to the kitchen for a bowl of Golden State Creamery ice cream, which their father brought home regularly, maybe making the McChesney children more tolerant of the sixty-foot glider taking shape in their home. Their mother, Grace, would become an accomplished pilot when, in later years, Leroy survived a heart attack. She figured she'd have to know how to land the family's airplane. It would be brother Jess Milo who would have to crash-land an aircraft. In his case, it was a four-engined B-24 Liberator, belly-flopped on an airstrip in Italy after being shot up by flak during a Fifteenth Air Force bombing mission in 1944.

Cal Poly, the object of Earhart's 1936 visit, was as integral as the McChesneys were in the development of local aviation. In 1927, the little agricultural school had added its program in engineering mechanics and aeronautics to the curriculum. (The first county airport, Clark Field, was built in 1928; it's no coincidence that both developments followed Lindbergh's solo transatlantic flight.) Poly's aeronautics program didn't waste time; in a foretelling of the later university's motto, "learn by doing," the students built their own airplane in 1928, dubbed "GlenMont," a tribute to their professors, Glen Warren and Monty Montijo, and a tribute, in its uncanny resemblance to the Ryan-built *Spirit of St. Louis*, to Lindbergh.[13]

It would be another remarkable local family, the Hoovers, who would preside over the maturation of flight in San Luis Obispo County, but as it had been with Lindbergh's influence, outside events—in this case, the approach of war—would play a role. The Hoover brothers, David and Chris, both products of Cal Poly's aeronautical engineering program, along with their brother-in-law, Earl Thomson, would win the right to manage the new county airport on its founding in April 1939. (Thomson's wife, Dorothy Hoover Thomson, was a long-lived and beloved local music teacher. In the 1950s, when Earl Thomson became the personal pilot to King Saud of Saudi Arabia, Mrs. Thomson taught music to some of the king's fifty-six children.)[14] In a series of articles in local newspapers in 1938–39, local political and commercial boosters were joined by the U.S. Army in their advocacy for the founding of the airport that would become

Central Coast Aviators in World War II

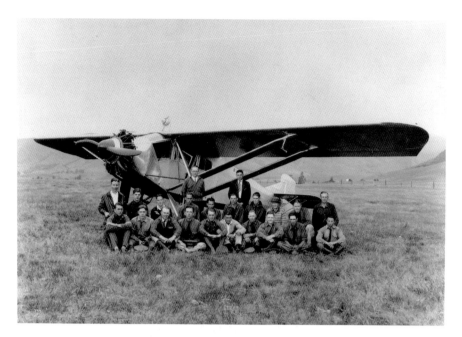

Justifiably proud Cal Poly students surround the airplane they built, "GlenMont," 1928. *Courtesy of University Archives, Cal Poly State University, San Luis Obispo, Special Collections and Archives.*

so identified with the Hoover family. The local National Guard unit, the Fortieth Infantry Division, based at Camp Merriam (later Camp San Luis Obispo), boasted a modest little grass airstrip adjacent to the officers' club for aerial photo and observation biplanes, but as Japanese incursions into China and German aggression in central Europe intensified, the Fortieth's commander, Major General Walter Story, was explicit in his support for a more modern airport that could be used by the division for newer, faster and larger military airplanes.[15]

It would be that unspoken but insistent awareness of the approach of war that would provide the Hoover brothers with both an airport and a thriving business in pilot instruction. Flying lessons, offered by the Hoovers, Thomson or a former Cal Poly second baseman, Ed Lauppe, were skillfully advertised with the images of high-powered airplanes soaring across the pages of local newspapers. The young flight instructors were given help from the government a year after the airport opened, when men eighteen to twenty-five years old with a year of college experience became eligible for government-subsidized flying lessons that

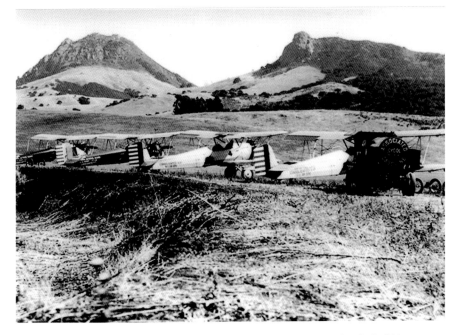

Fortieth Division observation aircraft at Camp Merriam, later Camp San Luis Obispo. Bishop Peak and Chumash Peak are in the background. *Courtesy of the Michael J. Semas Collection, Boeker Street Trading Company.*

would lead to a civil air license.[16] ("Not bound to military service," the Hoovers' newspaper ads reminded their readers, which was, of course, the hidden agenda behind the Civil Aeronautic Authority's tuition program.) Scores of young men, many from Cal Poly's aeronautical engineering department, became licensed pilots, their names published prominently in the local papers.

One local young man, a dairyman like the McChesneys, had already gotten his license by the time the big newspaper ad appeared. Elwyn Guido Righetti, a product of the Independence School just south of San Luis Obispo and of Cal Poly, had to scrimp to pay for the lessons he took in San Luis Obispo and Santa Maria. Not enamored of dairy farming, Righetti was enchanted by flying.[17] He was also an immensely talented pilot, and after learning to fly in a series of relatively docile civil airplanes, he would, in the U.S. Army Air Forces, find the perfect match for his gifts in a legendary fighter plane. It was small, sleek, fast and deadly. It was powered by a V12 Packard-Merlin Rolls-Royce engine marked, during high-speed passes, by its unmistakable sound, a high-pitched whistle complemented by a deep-

Learn to FLY

**Government Approved School
Certificate No. 210**

BOYS, 18 to 25, with one year's College Education are now eligible to learn flying, under the Civil Aeronautics Authority. The government pays your tuition. Graduates are given Private Pilot Licence. Not bound to Military Service. 72 hours ground work at Polytechnic College and 35 to 50 hours dual and solo instruction in actual flying.

FLYING INSTRUCTIONS for Anyone

HOOVER BROS. & THOMSON
SAN LUIS OBISPO FLYING SERVICE

David Hoover Chris Hoover Earl Thomson

San Luis Obispo County Airport 2 Miles South on Edna Road

Telephone 1957

SEE your CITY from the AIR

CHARTER AND SCENIC FLIGHTS

Luscombe Sales and Service

Aeronca Sales and Service

General Repairing Aero Photography

Hangar Space

The Hoover brothers and Earl Thomson advertise in the *San Luis Obispo Telegram-Tribune*, December 1940. *Courtesy of the* San Luis Obispo Tribune.

throated growl. Righetti's perfect match was a P-51D North American Mustang that he called "Katydid."

That meeting was three years in the future on December 7, 1941. That was when Righetti, who had joined the military in December 1939, was a flight instructor in Texas and learned that one of his students had been

killed in the opening of the American war.[18] Back home in San Luis Obispo County, families like the McChesneys would hear the first news bulletins about Pearl Harbor at about 11:30 a.m. In San Luis Obispo, the city's fire siren, affectionately known as "Ferdinand," began wailing as the signal for Fortieth Division soldiers to return to base at Camp San Luis Obispo, which sprawled along Highway One north of town. That division would ultimately fight in the Pacific War. No one yet knew this Sunday morning that two local sailors, Jack Leo Scruggs and Wayne Morgan, were already among that war's casualties. They had served and died on battleship *Arizona*, blown up at its berth in Pearl Harbor.

2

LEARNING TO FLY

Air Cadets and WASPs

Fighter pilot Elwyn Righetti and bomber pilot Jess Milo McChesney, the dairymen's sons, entered the U.S. Army Air Forces (AAF) to become part of a service branch that would ultimately include, by 1944, nearly 2.5 million young Americans. (The two would be joined, in 1943, by Elwyn's younger brother, Roger, who would, like McChesney, pilot a Fifteenth Air Force B-24.) These young men were, especially in the first two years of the war, when demand for combat pilots was intense, among the best and the brightest of their generation. It was air force commander Henry "Hap" Arnold, a hard-driving man prone to heart attacks, who insisted that this be so: Arnold argued that the rapid buildup of military aviators needed to fight a modern war called for the recruitment of men with some college education, flight experience, mechanical aptitude and/ or a demonstrated ability to learn skills quickly. The last was measured by the Army General Classification Test (AGCT). Arnold demanded that 75 percent of his personnel be made up of men who had scored 100 or above on the 150-item AGCT (roughly, the top 45 percent of all inductees in 1943).[19] It is a measure of Arnold's force of personality that army ground forces commanders fought the 75 percent rule bitterly throughout 1942, and they lost.

Once a recruit had been accepted for flight training, the path to his wings was long and arduous. In general, aviators went through four phases that lasted about ten to fifteen weeks each: preflight prep training, then primary, basic and advanced flight training. Finally, for bomber crews, advanced

Army Air Forces cadets on parade at Hancock Field, Santa Maria. *Courtesy of the Santa Maria Museum of Flight.*

training would be followed for a short but intense orientation period where they would learn both their duties and the aircraft that they would fly overseas when it was time for them to join the war.

For over three thousand potential naval aviators, preflight prep—the painful transition from civilian to air cadet—came at Cal Poly, one of some twenty colleges that would be chosen by the end of 1942 to begin the process of creating naval aviators. Six hundred cadets at a time, under the eye of Lieutenant Commander Harry Cook and Cal Poly president Julian McPhee, had taken over the campus by early 1943. (Cal Poly, which had traditionally offered two-year certificate programs, enrolled 664 students in 1940; civilian enrollment dropped to only 80 students as the flight prep program took precedence, and its cadets took over the campus.)[20] For the young men beginning to arrive in January 1943, their schooling was now "by the book," as former Cal Poly president Robert E. Kennedy wrote, "and 'the book' was the Navy manual provided to civilian instructors who were cautioned not to deviate from the 'Navy Way' of doing things—and we didn't. The campus became a ship; walls were bulkheads, floors were decks, and toilets were heads."[21]

Left: A preoccupied naval aviation cadet on the cover of Cal Poly's wartime magazine, the *Mustang Roundup*. *Courtesy of University Archives, Cal Poly State University, San Luis Obispo, Special Collections and Archives.*

Below: Stearman Kaydets being flown by naval aviation students and their instructors at Pensacola, Florida. *U.S. Navy.*

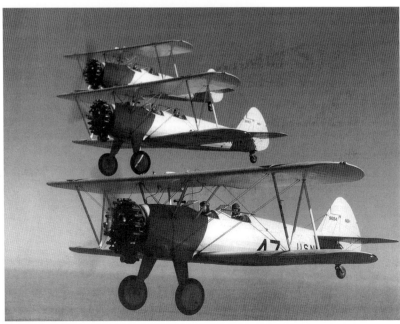

The "Navy Way" wasn't necessarily an ordeal. One cadet remembered a setting that was relatively idyllic, given the urgency of war then raging across the Pacific, where most of these young men were bound:

> [W]e lived in a one-story wood barracks, located in what is now the administration building [Dexter Hall, marked by its clock tower]. Our classrooms were also one-story wood emergency structures east of the old administration building. We ate our meals in a building just across the street from the old natatorium. An elderly lady ran the operation and the food was excellent.... We got our candy bars and other special items by making trips up to the Navy's Ships Service at Morro Bay.
>
> Weekends were spent traveling to Los Angeles or San Francisco via the Southern Pacific trains, or by hitchhiking. Some guys stayed on station and went to places like Mattie's at Shell Beach [Today's F. McLintock's—rumors persist that Mattie ran a bordello as well as an excellent steakhouse.] *and to Pismo Beach. Occasionally an escorted group of girls came in from another city for some on-campus coed recreation. Since it was an all-male campus, we had to have a Cal Poly Queen. We ran a contest where the men submitted pictures of their girlfriends and a committee selected the queen. She then came for a weekend of special festivities.*[22]

But the work was real, and it was difficult. For the potential pilots, the fifteen-week training program included classes in naval tradition and etiquette, math, physics, meteorology, Morse code and navigation. Emphasis on physical conditioning was intense—the cadets frequently began each morning of their ten-day on, two-day off training schedule with a run up to the Poly "P" on a hill behind the campus, supplemented by calisthenics, competitive sports and, of course, endless close-order drill.[23] Not every cadet completed the program: washouts were dispatched to the Great Lakes Naval Training Center for an uncertain future as enlisted men. For those who passed the fifteen weeks at Poly, their training had merely begun. In the next stage, they would meet, for the first time, their airplanes.

For both U.S. Navy and Army Air Forces cadets who survived the transition from preflight to primary training, that airplane would be a biplane, one the Army dubbed the PT-13 Kaydet (a later model, the PT-17, had a slightly larger engine). Originally built by the Stearman Company, which was bought out by Boeing in 1934, the two-seat trainer had a top speed of about 125 miles per hour and, in part because of its mandated blue-and-gold color scheme, was sometimes referred to as the "Yellow Peril."[24] The other reason for the nickname, of course, came from the frequency with which aviation cadets crashed their Kaydets, which was an automatic ticket out of the flight program and into the life of a dogface (foot soldier).

Another automatic ticket out, of course, came with a fatal training accident. At least eighteen San Luis Obispo County airmen were killed in World War II, and one of them, Frederick George Willis, died in primary, the first step in flight training, when his Kaydet began its death plunge near Lancaster, California. Both Willis and his flight instructor jumped from the doomed aircraft. The instructor's parachute opened. Willis's didn't. Even airmen in the most advanced stages of training—those about to head overseas—were subject to freak accidents like Willis's. First Lieutenant Cornelius James Norton of San Luis Obispo died in Louisiana when the engine of his P-39 Aircobra fighter malfunctioned; Second Lieutenant Randolph Donalson died in a midair collision between his twin-engined bomber, a B-25 Mitchell, and another B-25 on a cross-country training flight. The memorial, in South Carolina, misspells Donalson's hometown, San Luis Obispo. The most horrific accident involved a gunner, Sergeant Charles Eddy of Templeton. Eddy's B-24 Liberator was on a series of practice bomb runs over an Alabama air base when it suddenly dropped like a stone from twenty thousand feet. The pilot and copilot, who had to be fighting incredible g-forces, fought for control of the plane and succeeded—they leveled out the big bomber less than one hundred feet from the ground. When they turned their ship gently to the right to head back to base, it plummeted to the ground and exploded, killing the entire crew.[25] Army Air Forces trainees wrecked nearly five thousand aircraft during World War II; 3,500 paid the ultimate price for mechanical malfunctions or pilot error.[26]

Over eight thousand pilots in the U.S. Army Air Forces would go through primary training in Santa Maria at Hancock Field. Captain Allan Hancock, a one-time mariner and an oil entrepreneur, became attracted to flying at about the time of Lindbergh's solo flight. Much of Hancock's life would be devoted to philanthropy, and one early example of Hancock's generosity

The Hancock Field flight line. *Courtesy of the Santa Maria Museum of Flight.*

would be his funding of the first flight, in 1928, from Australia to the United States, undertaken by the crew of the trimotor "Southern Cross." Within a year, he had founded the Hancock College of Aeronautics on the site of today's Hancock College.[27]

In 1939, air force chief Hap Arnold met with Hancock and the owners of eight other flight schools and requested that they begin training military pilots in a program that, Arnold admitted, had not yet been approved or funded by Congress. The nine heads of the flight schools immediately agreed to Arnold's proposal, and in July 1939, the first forty aviation cadets arrived at Hancock Field.[28] At the Santa Maria Museum of Flight, adjacent to today's airport, curators have preserved class pictures and records, including those of one of the most remarkable classes to graduate from primary at Hancock, Class 1940-A. It included at least five fighter aces; seven men who would participate in the Doolittle Raid on Tokyo in 1942, including Major Ted Lawson, the author of *Thirty Seconds over Tokyo*; two future full generals in the U.S. Air Force; and a student who wouldn't make the cut as a pilot, but would go on to become a B-24 bombardier. When his Liberator was shot down over the Pacific, Louis Zamperini's stoic courage—including spending forty-seven days adrift at sea, then enduring torture and beatings as a Japanese prisoner of war—would be captured vividly in Laura Hillenbrand's book *Unbroken*.[29]

Central Coast Aviators in World War II

When aviation cadets arrived at places like Hancock or Ryan Field in San Diego, where Elwyn Righetti went through primary flight training, or the Mira Loma Flight Academy in Oxnard, the site for B-17 pilot Eugene Fletcher's primary, the first order of business, especially once the war had begun, was to remind the young gentlemen that they were *not* fliers. They were instead "dodos"—flightless birds—and, in Fletcher's experience, that reminder was driven home when he and his classmates were ordered to remove the wing-and-propeller badges from their collars and uniform caps. They could wear them again once they'd passed primary.[30] They learned to fly their PT-13s, beginning with basic handling and ending with acrobatics, over a ten-week course, soloing about halfway through, and as World War II historian John McManus noted, "Cadets were liberally washed out of primary flight training for any perceived weakness—from airsickness to rough landings to poor stick-and-rudder techniques."[31] Crashes weren't uncommon: Righetti vividly remembered a Kaydet landing atop another trainer that was taxiing on the Ryan school's airstrip. Miraculously, no one was hurt, but the air force was now smaller by two airplanes and one aviation cadet.[32]

Hancock aviation cadets meet local young women. Sadly, many of these young fliers were near the ends of their lives. *Courtesy of the Santa Maria Museum of Flight.*

Central Coast Aviators in World War II

Dorothy May Moulton Rooney (*center*) and her fellow pilots at Williams Army Air Force Base, Arizona. *Courtesy of Texas Women's University.*

For those who made it through primary training, a ten-week basic course followed, this time in more powerful aircraft (Righetti's BT-9 intermediate trainer, a monoplane, had nearly twice the horsepower of the little Kaydet biplane used in primary) while learning more complex skills—instrument flying, when a hood or heavily billed helmet blocked a cadet's view out of the cockpit, night flying and formation flying. The basic phase also saw a second kind of winnowing for the aviation cadets: those who weren't rated as potential pilots—about 40 percent of the total—would be assigned to schools for navigators or bombardiers, where they would retain their officer status; others would specialize as flight engineers or gunners and would emerge from the end of their training as sergeants.

For those destined to become pilots, their performance evaluations during basic phase would result in them being assigned to advanced training in either single-engine airplanes as fighter pilots (cadets hoped for this—flying a fast fighter was seen as glamorous and adventurous, and young men loved the stories of World War I "knights of the air") or to multi-engined aircraft for training as bomber pilots. First Lieutenant Elmer Hagerman from Paso Robles was another local casualty in advanced bomber training—but as an instructor—when, in 1944, his twin-engined AT-18 stalled and crashed near Beeville, Texas, during a navigation exercise.[33] Over three hundred miles northwest of Beeville, at Avenger Army Airfield, a new crop of pilots was

volunteering to face the same kind of hazards Hagerman and his comrades faced. They were pioneers. Collectively, they were called WASPs—Women's Airforce Service Pilots.

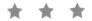

One WASP was in trouble at eight thousand feet. Dorothy May Moulton Rooney flew as a test pilot; the AT-6 "Texans," trainers that she flew, and loved, were just out of the shop at the Williams Army Air Field in Arizona. To escape the desert heat, Rooney would take her Texans over the mountains and pine forests, where the air was cooler. Then, she could open the canopy to let the wind rush into her hair and into the billowing sleeves of the WASP "zoot-suit," a shapeless coverall that was the closest she would ever come to a uniform while flying. But her celebration on this flight was cut short when the Texan's engine cut out. Rooney would later admit that she was not fearless, but as it turned out, fatigue, rather than fear, was a far more serious problem for pilots like herself. ("Of course, you won't fly here," the Williams base commander told her when she'd first arrived. The shortage of trained pilots for test flights soon proved him wrong. She flew constantly.) Whatever fear she felt as her engine quit was soon replaced by the automatic response World War II pilots described frequently: a moment after the fear hits, the training takes over. Rooney went through her checklist as the plane gradually lost altitude.

Nothing happened.

She contemplated actually using the parachute she sat on—no airman or WASP had parachute training—but reminded herself that she was above rocks and trees. Visualizing herself dangling helplessly in a pine tree, she vetoed the impulse to leave the plane. She went through her checklist again, getting closer and closer to impact. She even tried, ridiculous in the Arizona heat, throwing the switch for the carburetor heater, a cold-climate accessory.

The engine started.[34]

Today, Rooney, a retiree in Los Osos approaching her 100th birthday, is justifiably proud of her service as one of some 1,100 WASPs who earned their wings during World War II (25,000 young women applied for the program). The result of a 1943 merger of two earlier programs, the Women's Auxiliary Flying Squadron and famed aviatrix Jackie Cochrane's Women's Flying Training Detachment, the WASP program would accept Rooney for training in 1944 at Avenger Field in Sweetwater, Texas—a misnomer,

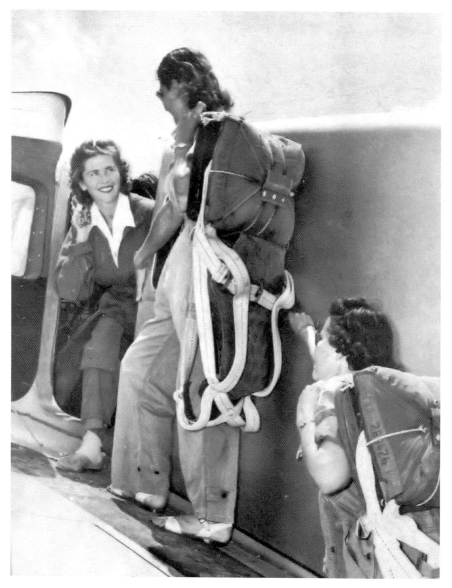

A new WASP crew takes its turn during multi-engine flight training *Museum of the U.S. Air Force.*

Rooney later observed—where candidates lived in spartan conditions (six to a barracks room, six to another, with a common bathroom in between) and went through the same program that their male counterparts, the aviation cadets, went through.

Once they'd graduated, WASP pilots served on dozens of bases throughout the United States, where they tested aircraft, towed targets or ferried aircraft, including four-engined bombers like the B-17 and B-29, from factory to air bases or embarkation points. Thirty-eight of them were killed in accidents, a ratio lower than that for male pilots. One of them was a young Santa Barbara woman stationed at Blythe Army Airfield in the California high desert. Betty Pauline Stine died in 1944 in the exact circumstance that Dorothy Rooney had feared: when sparks from the engine of Stine's AT-6 set the plane's tail on fire, she bailed out just before the plane flew into a mountain and exploded. Miners saw Stine's parachute and made their way to her, but she'd been dragged by her parachute across the rocky terrain and was gravely injured—she later died at the base hospital.[35] Another WASP death remains one of the most haunting tragedies of World War II at home: Thirty-one-year-old Gertrude "Tommy" Tompkins-Silvers disappeared in November 1944 while ferrying a P-51 Mustang from Los Angeles to the East Coast. No trace of the pilot or her fighter has ever been found; the military could only speculate that poor visibility and an engine malfunction might have led the Mustang to crash into Santa Monica Bay shortly after takeoff.[36]

The contempt that Dorothy Rooney had encountered on first meeting her commanding officer at Williams Field followed WASP pilots even into death. Since these young women were not fully "militarized," or formal members of the U.S. Army Air Forces—their status was that of civilian contractors—the AAF felt no obligation to pay for their funeral expenses. Rooney remembered her classmates at Avenger Field taking up collections to help pay for transport home of the remains of pilots killed in training, as well as the train fare for the WASP who volunteered to accompany the casket to the dead pilot's family. Jackie Cochrane herself paid for the funeral of at least one pilot; the family of another, Mabel Rawlinson, killed in North Carolina, defied military protocol. Even though their daughter was technically a civilian, Rawlinson's parents insisted on draping her coffin in the American flag.[37]

Another WASP, Sylvia Barter, who grew up in Solvang, felt "a deep sense of sadness" when the program was summarily ended in December 1944. Citing a sufficiency of manpower and the seeming imminence of the end of the war, the military felt the program superfluous. Each WASP pilot—Barter had flown both single- and twin-engined planes, and like Rooney, she had a soft spot for the AT-6—had to pay for her own way home. The insults didn't end with the end of the program:

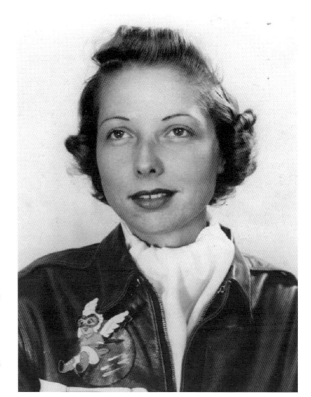

Right: Sylvia Barter, WASP flier. *Courtesy of the Barter family.*

Below: Pilots eye their aircraft—the AT-6 Texans so beloved by Dorothy May Moulton Rooney and Sylvia Barter. *Museum of the U.S. Air Force.*

it would take thirty-two years and the intervention of Arizona senator Barry Goldwater to pass the GI Bill Improvements Act of 1977, which finally accorded WASPs formal military status. Only ninety-six WASPs remained in 2016, when one of their own, Elaine Harmon, was buried with honors at Arlington National Cemetery in a ceremony that had originally been vetoed by the secretary of the army. It took a special act of Congress to overrule that decision.[38]

Sylvia Barter took thirty years off from flying before renewing her pilot's license in 1976. In the meantime, she had raised four children—in 1947, thanks to twins, she had four children under three years old to deal with. She and her husband, a veteran B-24 Liberator pilot, bought a Cessna and enjoyed cross-country flights until she was in her late seventies; she was also a member of the 99s, a club for women pilots.

Both Rooney and Barter had wanted to fly ever since they were little girls, and they found great strength and freedom in the air. Rooney remembered that "it was fun. I think I just had the best time of my life flying. Even the parts that were scary brought something out of me that was fun. I proved I could do it!"

And Barter's children remembered their mother as both courageous and loving in a touching 2009 obituary: "We are so proud to have the bragging rights that this honorable woman was our Mom."[39]

3
BOMBER CREWS
Bands of Brothers

After finishing gunnery school in Yuma, Arizona, Oklahoma-born Corporal Albert Lee Findley Jr. reported to Hammer Field, just outside Fresno, and met his B-24 bomber crew:

> *I met my pilot, Byron Johnson, from Oklahoma; my copilot, James Gill, from California; my navigator, Robert Cramer, from California; my bombardier, Nolan Willis, from California; my engineer, Morgan Fowler, from South Dakota; my nose gunner, Homer Smith, from Texas; my left gunner, Theodore Mabee, from Illinois; my right waist gunner was James Walter…and he was from some eastern state that I don't recall, and my tail gunner was Johnny Gates—he was from some eastern state, also. That was the crew. Plus me.*[40]

It's hard to fault Findley for not remembering every one of his crew members' home states. The Los Osos retiree was speaking from memory in 2013, nearly seventy years after he'd met the men who became "very dear" to him. The feeling must have been reciprocated, because Findley, in an oral history interview that has become part of a Library of Congress collection, emerges as engaging, well spoken and warm—traits that may have failed him only once, when, two-thirds of the way through his combat tour, he was shot down over Germany.

The first thing a downed airman would do, if he was able, was seek out his surviving comrades. It was an obligation that had begun in the very last

Above: Copilot Melvin Engle of San Luis Obispo (*front row, center*) with his 466th Bomb Group B-24 aircrew. *Courtesy of Chris Brassfield, American Air Museum in Britain.*

Left: Master Sergeant Al Findley, 1944. *Courtesy of Albert Lee Findley Jr.*

stage of training. Finally, the component parts of what would become an aircrew would meet one another and, as Findley did, their aircraft at about the same time. Findley remembered, with a sense of relief, that their brand-new B-24 Liberator came with a ball turret on its underside. Air force commanders in the South Pacific had ordered the turret removed to improve the big bomber's maneuverability.[41] What Findley and his new crew realized was that they were headed for Europe—a relief because of the oppressive climate and primitive conditions servicemen had to endure in the Pacific.

So a crew like Findley's would spend several weeks in what was called "phase training"; they were getting to know the

Lieutenant Robert Abbey Dickson. *Courtesy of the Dickson family.*

airplane and one another. For B-17 pilot Robert Abbey Dickson of Morro Bay, that time was spent in Alexandria, Louisiana, and consisted of several weeks of cross-country flying—one mission took them to Yucatan and back—practice bomb runs and, for the gunners, practice firing at targets dropped into the Gulf of Mexico.[42] Copilot Robert Potter Dwight of San Luis Obispo picked up his B-17 and crew in Nebraska. "That's where I formed this very close friendship with nine other guys," he remembered. Technically, he was an officer, but the line between officers and enlisted men was much more fluid in the AAF. Dwight and his aircrew played volleyball, drank beers and talked shop together. "We became very close," he said, and one factor that may have united them immediately was the sight of what Dwight called the "beautiful airplane" that would be *their* B-17.

For most of the war, San Luis Obispo County airmen flew in two types of heavy bombers—the B-17 Flying Fortress or the B-24 Liberator. (By 1944, some would fly the B-29 Superfortress over Japan.) While crews devoted to their B-17s derided the more ungainly B-24 as "the box the B-17 came in," Liberator crews were just as dedicated to their ships. More B-24s were manufactured—nineteen thousand, with eight thousand built by the retooled Ford Motor Company at its Willow Run plant alone—than any heavy bomber in history. If the B-17 has a more glamorous image, it's

largely due to both its sleek looks and to Hollywood: newly-minted Major William Wyler, who had directed *Jezebel*, *Wuthering Heights* and the stirring wartime drama *Mrs. Miniver*, immortalized the crew of the "Memphis Belle" in the 1943 documentary of the same name. Belle's crew was the first said to have completed the required twenty-five missions over Europe (a milestone more likely attributed to a B-17, "Hell's Angels," part of Clair Abbott Tyler's 303rd Bomb Group, but "Angels" had no Hollywood directors aboard), and so the B-17 became immediately and intimately familiar to Americans.[43] Despite Wyler's documentary, it was, in the final analysis, the Liberator that may have won the most famous Hollywood advocate: James Stewart, who'd already made films like *Mr. Smith Goes to Washington* and *The Philadelphia Story*, became the commanding officer of a B-24 squadron and flew twenty combat missions over Europe. "He was a hell of a good pilot," one of his bombardiers remembered.[44]

Perhaps the best way to deal with the debate between B-17 and B-24 enthusiasts is to simply leave it alone. Each plane had it advantages: the B-17 could take substantial punishment and was far easier to fly in formation—B-24s demanded considerable muscular strength from their pilots—but the Liberator was faster and carried a heavier payload.[45] The B-17 was more numerous in the European theater while the B-24 was the more common heavy bomber, until the advent of the B-29 Superfortress, in the Pacific.

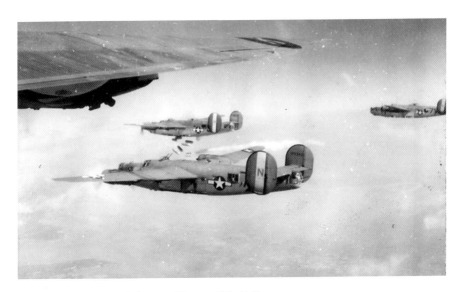

B-24 Liberators on a mission over France. *U.S. Air Force.*

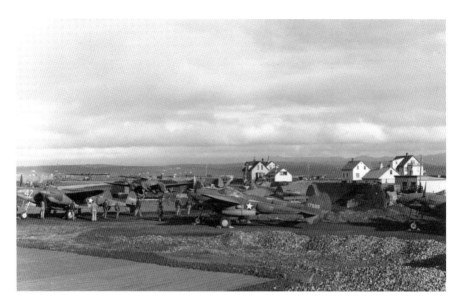

P-38 fighters refuel in Iceland on their flight to their bases in England. *Museum of the U.S. Air Force.*

Once they'd picked up their B-17, copilot Robert Dwight and his aircrew were ordered to fly it to their air base in England, a trip taken in legs from Nebraska to Grenier Field in New Hampshire, then to Goose Bay in Labrador, then overnight to Iceland, from Iceland to Shannon, Ireland, and finally from Shannon to their assigned base, with the 447th Bomb Group at RAF Rattlesden in Suffolk. Robert Abbey Dickson took a different route to his base in England with the 91st Bomb Group: he shipped out on *Queen Mary*, drab in her wartime gray. The great ship, fast enough to outrun U-boats, was capable of carrying an entire division. Dickson remembered a kindly waiter named Judson who continued *Mary*'s excellent service with the young American fliers who were packed into a stateroom once intended for affluent couples traveling in peacetime. He felt sorry, on the other hand, for the enlisted men, packed even more tightly into what had once been the liner's swimming pool. Major Harold Schuchardt, who lived out his life in Los Osos, was bound for duty in Italy, so his transatlantic trip was in a B-17 that flew from Virginia to Brazil—he was enthralled by the immensity of the Amazon Basin—to North Africa and, finally, in May 1944, to its home base in Amendola, Italy. Once they'd reached their overseas bases, the flight crews, after a short orientation period, would finally enter combat after a year's training.

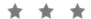

Each member of a heavy bomber's flight crew, typically made up of ten men, was a specialist. The AAF operations manual for the 303rd Bomb Group (by 1945, a bomb group typically was made up of seventy-two airplanes, divided into four bomb squadrons) specified the duties of each member of the aircrew of a B-17: the pilot was also the airplane commander and, as such, was expected to elicit "obedience and respect" but also be "friendly, understanding and firm." The latter qualification, especially the term *friendly*, may have been one unique to the air force and is consistent with copilot Robert Dwight's memories of a crew made up of comrades, without the sharp divide between officers and enlisted men typical of the rest of the military. A good pilot genuinely cared about his aircrew—Robert Dickson demonstrated this trait as early as his *Queen Mary* voyage, where he had the decency to worry about the men stacked in their swimming-pool bunks—and this may have been the single most important factor in maintaining aircrew morale, an intangible quality that was both important and, given the stress of air combat, fragile. If pilots were also expected to command obedience, this is a quality that may have emerged, in great part, from their flying skills. Harold Schuchardt, while serving as a copilot, marveled sixty years later at the skill of his Fifteenth Air Force pilot, who brought their damaged B-17 down safely on a Corsican airstrip that was too short for heavy bombers. Schuchardt could see, through the plane's windscreen as they were setting down, a junkyard of wrecked bombers at the airstrip's end that *proved* this was not a place intended for B-17s.[46] His pilot brought the landing off short of the wrecks, and both Schuchardt and the rest of the crew must have realized that the young man in the left-hand seat was their best chance at surviving the war.

The young man in the right-hand seat, the copilot, was expected to know, or learn, every skill the pilot had mastered and, in addition, be conversant in radio operation and navigation; he was considered a bomber's "chief engineer." The third officer, stationed in the nose section of a B-17 or B-24, was the navigator, selected for, among other things, his talent for mathematics. Navigators completed a twenty-week advanced course that taught them radio and celestial navigation as well as dead reckoning. With the navigator was the final officer, the bombardier, who took over the plane once it began its bomb run at the IP (initial point) and who used the state-of-the-art Norden bombsight to target the plane's bombload.[47] (By

1944–45, the Eighth Air Force's ordnance dropped on European targets was made up of 100- to 250-pound high explosive bombs, with 500- to 1,000-pound bombs used on industrial facilities.)[48] As it turned out, the precision daylight bombing policy that the American air forces employed was less than precise; postwar surveys indicated that, in Europe, only about 31 percent of the bombs dropped landed within one thousand feet of the intended target, or aim point.[49]

Six enlisted men, usually all sergeants, completed the crew. They included the top turret gunner/flight engineer, whose station was behind the pilots and who monitored the bomber's engine performance, electrical and hydraulic systems; two waist gunners, who operated Browning machine guns through openings in the bomber's left and right sides, which meant that they were buffeted by propwash and wind-blast at subzero temperatures. The tail gunner, men like Dick Cowles of Arroyo Grande, who flew thirty-four missions with the 390th Bomb Group, was by himself at the plane's rear, just behind his B-17's tail wheel, perched on a bicycle seat, and he operated

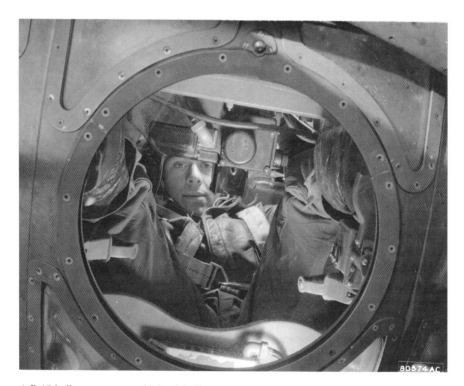

A B-17 ball turret gunner. *National Archives.*

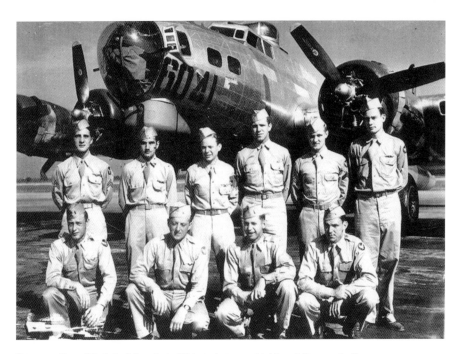

Sergeant Donal Laird of San Luis Obispo (*top row, third from left*) was a ball turret gunner killed on his first mission in the B-17 in the background, "Strictly G.I." The wristwatch Laird was wearing that day was returned to his family in 2016. *Courtesy of the Ninety-First Bomb Group Association.*

twin machine guns.[50] Usually the ball turret gunner was the smallest man in the crew. He was suspended in a motorized bubble, a Sperry turret, under the fuselage—there wasn't room for a parachute, kept just outside—and he also fired twin .50-caliber machine guns. The radio operator manned a single Browning machine gun whose barrel protruded from a retractable hatch above his station, behind the flight engineer. The B-24 boasted two robust machine guns in a forward turret—a B-17 bombardier operated a single .30-caliber nose gun, a weapon that was badly underpowered and so left the bomber vulnerable to frontal assault. That weakness was corrected with the B-17 "G" model, which began production in July 1943, featuring a motorized chin turret with twin .50-caliber guns.[51] This much firepower was intended to make the American bomber as formidable defensively against enemy fighters as it was offensively. Aircrews would find out almost immediately that, as terrifying as those fighters were, they were but one of many hazards.

Enemy antiaircraft fire may have been even more dangerous. Radioman/gunner Albert Lee Findley flew his first mission in his B-24 on September 5, 1944. As he and his crew approached the target, Findley was suddenly enchanted:

> *I saw a lot of silver things floating out of the air, and I thought "if that's flak, it's very lovely." Shortly after that, I saw the flak, big black bursts, and it shook the airplane. The silver things I saw were chaff that some of the airplanes dropped to foul up their radar. It didn't work that day, because a lot of the aircraft were hit over the target, including us.*

In fact, Findley's bomber was so badly damaged by flak—radar-directed groundfire from German batteries (the chaff he'd seen was made up of slivers of aluminum foil)—that the pilot had to crash-land the plane in France and, fortunately for Findley and his aircrew, on French soil that had just been liberated by American ground forces. "If this was the *first* mission," a smiling Findley remembered decades later, "I wasn't sure I could make *thirty*."

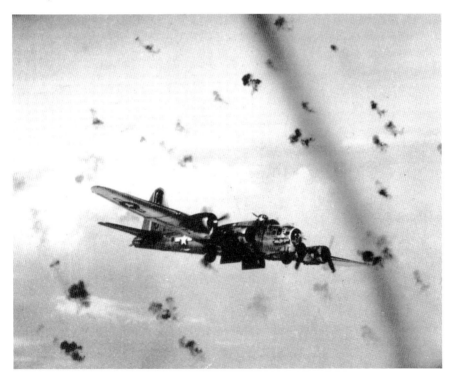

Flak bursts surround a B-17 on its bomb run. *Museum of the U.S. Air Force.*

Flak, from the German word *Fliegerabwehrkanone*, or "antiaircraft cannon," was psychologically devastating to World War II fliers, because, unlike their encounters with fighter planes, there was simply nothing they could do to fight back. The twenty-pound enemy shells, fired from ground batteries that were dense around key targets, exploded in angry black puffs that sent steel fragments slicing through wings, fuselage and crewmen. Flight engineer Al Spierling of Arroyo Grande counted over one hundred holes in his B-17 after one mission; on another, shards of flak sliced the oxygen lines necessary to survival at twenty-five thousand feet; the waist gunners and tail gunner in Spierling's ship kept passing out—symptomatic of anoxia—until he could repair the system.[52] Bomber crews could hear the flak fragments hit as the shell exploded close by, like gravel scattered on a tin roof. They would watch in amazement, as Spierling did on several missions, as gaping holes appeared in the airframe or, in Albert Findley's case, as an engine caught fire from a flak hit.

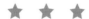

As if enemy fighters and flak weren't enough to worry about, bomber crews also had to deal with the elements: the oxygen supply, of course, was critical at missions flown in unpressurized cabins at twenty-five thousand feet. Masks were donned once the aircraft reached ten thousand feet, and it was the bombardier's responsibility to do "oxygen checks"—to check in, via intercom, with each crew member every five minutes. But the cold—Radioman Findley remembered temperatures at forty below zero—impinged on breathing, as well; any moisture inside the oxygen mask froze, blocking the air supply, something a crew member might not notice until one of his comrades lost consciousness. (Urine froze as well, so the "relief tube" provided each bomber crew frequently proved useless; veterans used buckets or just relieved themselves inside their clothing.)

Clothing was crucial to survival as well; skin exposed only momentarily at altitude was subject to frostbite, so airmen dressed in layers, described in a 1997 U.S. Air Force paper:

> *In the spring of 1943, a typical combat dress for a B-17 gunner consisted of: heavy woolen underwear, two pairs of lined wool socks, a modified F-1 electric suit* [itself unreliable—if one element went out on

the suit, like 1950s Christmas lights, the entire suit failed], *RAF designed electric gloves and socks, standard A-6 boots, and A-4 coveralls with a B-5 helmet. Additionally, some men wore a leather A-2 jacket over the coveralls. If an electric suit was not worn, the standard protective garb was the heavy fleece-lined B-6 jacket and A-5 trousers in its place. Clearly, all this clothing was a lot to wear and maintain and became cumbersome while trying to perform even the simplest task.*[53]

With his ship shot up by flak on one mission, a bundled-up Robert Dickson, then flying in the right seat as copilot, wryly remembered how much easier it was to exit his plane to bail out when compared to the struggle it had been to get into the seat at the flight's beginning.

Hours of discomfort were punctuated, of course, by moments of appalling violence, as fliers saw their comrades' bombers explode suddenly in midair or fall, in agonizing moments, to earth. Longtime Cal Poly education professor Richard Vane Jones was a B-26 medium bomber

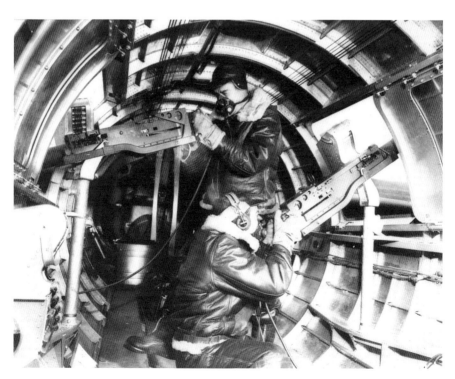

Waist gunners wear the warm clothing necessary to survival at high altitude. *Museum of the U.S. Air Force.*

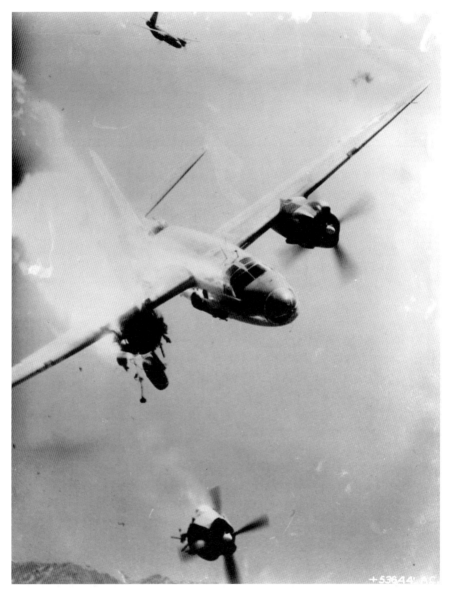

A direct hit on a B-26 Marauder, the kind of bomber piloted by Cal Poly professor Richard V. Jones. *Museum of the U.S. Air Force.*

pilot who saw the plane just ahead in his formation hit by flak and come apart. The doomed plane's wing just missed Jones's aircraft overhead as the fuselage passed just as closely underneath. "I've been a lucky, lucky person," Jones admitted later.[54] Technical Sergeant Henry J. Hall, a

Kansan transplanted to Bakersfield before the war and then to San Luis Obispo County afterward, was a gunner in the Ninety-First Bomb Group, the "Ragged Irregulars." Hall witnessed a horrific chain reaction over Holland: a swarm of German fighters singled out a B-17 ahead, and the multiple hits on the bomber registered for him when he saw the right-side landing gear listlessly drop and an engine on the right wing catch fire. When the out-of-control bomber began its final plunge, it clipped two more B-17s in the formation—both of them went down as well. It was the hardest of days for Hall's bomb group: they lost six B-17s on a mission that gained nothing: their primary target, a ball-bearing factory near Berlin, was obscured by clouds, so the Ninety-First dropped their payloads on "targets of opportunity"—on this day, Hall remembered, on a little crossroads town that probably contributed little to the Nazi war effort.[55]

That was Hall's first mission. He was twenty years old when he saw the three Ragged Irregular bombers plummet to earth together. Many members of his bomb group were even younger. Some of them, thanks to crafty misdirection aimed at recruiting sergeants pressured to meet their quotas, were as young as sixteen. Far below them, in German cities like Hamburg and Dresden—or in relatively obscure Japanese cities like Toyama, the size of Chattanooga, or Kagoshima (the seat of the prefecture from which most San Luis Obispo County Japanese had emigrated), the size of Richmond, Virginia—the ashen bodies of schoolchildren stained sidewalks and streets.

The young fliers, of course, saw events that no human being is meant to see, and they would see them over and over again for the rest of their lives, which stretched into the first decdes of the twenty-first century. Some of them cracked. They were not cowards. When Second Lieutenant Dwight first reported to his bomb group, a bunkmate muttered ominously about buzzbombs (German V-1 flying bombs) overhead where there were none. The man was a veteran. He disappeared from his bunk soon after Dwight's arrival, doubtless sent to the care of AAF psychiatrists. Some of the fliers had the audacity, like Joseph Heller's Yossarian, to question the sanity of what they were being asked to do: when Dwight's tailgunner was hit in the head by flak—it circled his head inside his flying helmet and landed, still hot, on top. Miraculously, he was unhurt. But he marched into the commanding

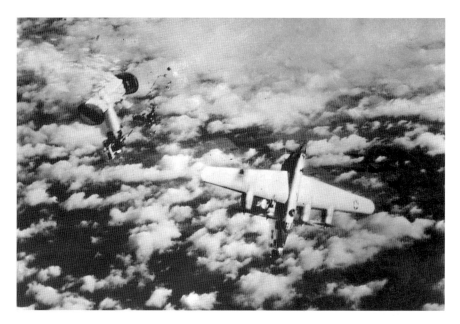

A B-24 Liberator comes apart in the skies over Germany. *Museum of the U.S. Air Force.*

officer's office after the mission and said simply, "I quit!" He was busted to private. He did not care.

Sixty years later, Dwight was certain that he never could have quit. One day, when his premission briefing officer pulled back the curtain to reveal the route to that day's objective, it was Berlin. There was a sudden, spontaneous and unashamed wail from one of the officers assembled in the briefing room: "I WANT TO GO HOME!" Dwight was nineteen years old and allowed, in his older years, that maybe what kept him going was that he was dumb.

But it wasn't stupidity that saved young men like Dwight from quitting. It was, perhaps first, loyalty to their crewmates—their "band of brothers"—augmented by the training that they'd received in their months of schooling as cadets and then as specialists. Dwight didn't think about what was happening around him, instead he was preoccupied with his job. "You just do it," he said. Pilot Robert Abbey Dickson admitted what nearly all of them did: "You're scared. You've got all kinds of concerns, but that's when the training kicks in. Once you get into the airplane, start the engines, taxi out, that's what you [were] training for."

Another factor that enabled these young men to survive was their youth; there is a feeling of invincibility that is the sole province of young people. B-26 pilot Richard Vane Jones noted:

> *If we knew on a mission that half the people were going to be destroyed and the other half would live, we would automatically feel sorry for that half that would be destroyed, because it wasn't going to happen to us. That's a mental set that has no logic; it was just something that helped you maintain some semblance of sanity and keep you going.*

Prayer helped the young men cope as well, but Jones was not a praying man. On one of his last missions, the target was a train yard alongside a river where, the day before, German flak guns had exacted a fearful toll among the American fliers. When his aircrew had boarded for a second day's assault on the target, there was absolute silence among Jones's men. It was completely out of character—like most young Americans, they were inveterate wisecrackers. Jones sensed their fear. So he said a prayer over the intercom as they waited on the taxiway.

"It was the most flak-free mission we ever had," Jones remembered.

4
THIS SEAT OF MARS

This royal throne of kings, this sceptred isle,
This earth of majesty, this seat of Mars
...This precious stone set in the silver sea
...This blessed plot, this earth, this realm, this England.

—*Shakespeare,* King Richard II

If there was a military historian with a gift close to Shakespeare's, it was another Englishman named John Keegan. Keegan was a little boy in the English countryside, in Somerset, when the Americans began to arrive in late 1943 and into the spring of 1944. Little English boys had lived for years with the deepest of privations—thanks, in large part, to the U-boat campaign that had nearly starved Shakespeare's "sceptred isle" to death—and then the Americans came. They were, as Keegan later said—for once at a loss of words while narrating a documentary on the 1918 turning point of World War I—"Well, they were *Americans!*" By which he meant they were boisterous, cocky, well fed, well clothed and, thank God, friendly, with an innocence and immediacy that was distinctly American. Their World War II counterparts taught English boys baseball, and they flirted with their big sisters and married some of them—but most of them not—which meant that little boys Keegan's age would inherit littler half-Yank nieces and nephews. Most of all, they were generous. There seemed to be no end to their Hershey bars (there wouldn't be after the war, either, when, during the Berlin Airlift,

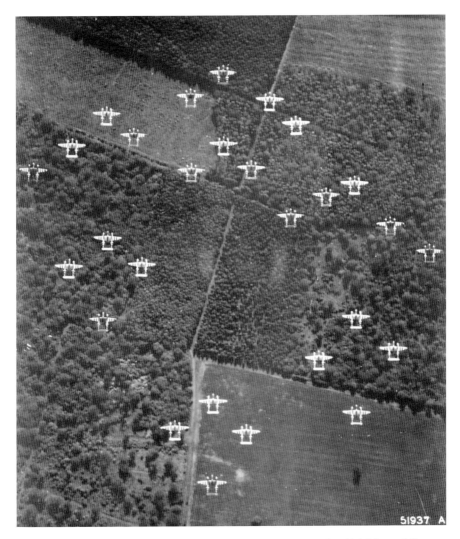

P-38 Lightnings, with their D-day identification stripes, over Normandy, 1944. *Library of Congress.*

one of bomber pilot Jess Milo McChesney's comrades, Gail Halverson, airdropped Hershey bars, floating on little parachutes, to the hungry children of blockaded Berlin) and no end to the rough affection for children that came with these big, loud men from across the sea.

And then they were gone. Keegan has vividly described the early morning dark when that happened, when the chinaware and modest family crystal on every shelf in the Keegan home began protesting, rattling an alarm so

GIs introduce English war orphans to baseball. *Imperial War Museum.*

loud that it woke the family up, if the motion beneath their beds hadn't already made them sit bolt upright. The anxiety of Keegan's family, their neighbors and other families all across East Anglia was relieved only when they went outside. Then anxiety gave way to wonder. They could feel in their breastbones the vibrations—"the grinding forced you to the

ground," Keegan remembered—of the engines of thousands of airplanes, but they could see only dim red and amber lights in the sky, heading east, toward France. Some of the Amerians Keegan had grown to love so quickly, his heroes, were on those airplanes, and tens of thousands of more, his heroes, were riding deathly pale on landing craft corkscrewing in foul Channel waters, and they were all headed for Normandy.[56]

It was D-day.

For the two years before D-day, the Americans in England who had been carrying much of the nation's fight to Nazi Germany were the airmen of the Eighth Air Force. They made up forty-nine bomb groups and twenty-two fighter groups, and their bases were seventy-one airfields concentrated in East Anglia, from Norfolk south to Essex, in places that must have sounded quaintly medieval to American ears: Bury St. Edmunds, Knettishall, Little Staughton, Matching Green, Molesworth, Snailsworth, Snetterton Heath and Thorpe Abbots.

George Bernard Shaw's charming line about "two peoples separated by a common language" must have rung true, then, for young men, newcomers to England who'd ferried their bombers from Labrador (or for the luckier men, like Robert Abbey Dickson, who'd shipped out on *Queen Mary*, or future Cal Poly professor Richard Vane Jones, who'd made his trip on *Queen Elizabeth*). Dickson's luck held: when he first arrived in England, he was sent to the 381st Bomb Group, where he flew two orientation missions as a copilot. The 381st's base was American-built, at Ridgewell, Essex, which meant that it had been built quickly in prefabricated stages by hardworking soldiers, black men, in army construction units. Bases like Ridgewell were marked by Quonset hut barracks, each with a single, feeble, coal-burning stove, muddy streets and mercilessly cold showers. But Dickson was quickly transferred to the 91st Bomb Group, based at RAF Bassingbourn, and the RAF—Royal Air Force—prefix made all the difference. An 8th Air Force Base with the RAF designation had originally been built by the British, and given Britons' stubborn reluctance to give up their island, such bases had been built to last. Bassingbourn had paved streets and central heating. Dickson was delighted. It was, he remembered, almost like a country club compared to the 381st's home base.

Army food wasn't country club fare. Bill Mauldin, the great cartoonist who created the imaginary Willie and Joe, his comrades in the Italian campaign, once remarked, without malice, that his mother was the worst cook in the world. Then he encountered army food, which was infinitely worse.[57] At least airmen understood that they were fed better than men like Mauldin, dogfaces, who commonly used GI powdered lemonade to wash their socks. Still, even in the AAF, the green-hued powdered eggs, along with the ubiquitous Spam, were breakfast standards, and creamed chipped beef on toast—referred to as "shit on a shingle"—followed airmen across the Atlantic from the air bases stateside where they'd first encountered what seemed to be, to the military, a perverse culinary masterpiece. Radioman/gunner Albert Lee Findley Jr. found little relief off base. "English food took some getting used to," he admittted tactfully. (Many years after the war, Findley and his wife would live in England as the proprietors of an antique shop.) One vegetable, brussels sprouts, was as common to English fare as Spam was to American mess halls, and at war's end, many English-based GIs swore they would never eat them again.

There were other features of English culture that the Americans found more to their liking. Airmen immediately found pubs near their bases, and the attraction was powerful. Historian Donald Miller writes of the 1943 arrival of an AAF engineer battalion, charged with laying out an airstrip outside the village of Debach, near the North Sea. Their discovery of what English called "the local," this one called the Dog, resulted in the Yanks buying so many rounds "for the house"—the last round, just before closing time, was for forty-seven drinks—that the next day, a doleful little sign was posted outside the Dog: "No beer." It was, Miller notes, the first time the pub had been closed in 450 years.[58] The Americans, of course, also found young English women to their liking as well. The War Department discouraged what were called "special relationships" and made it nearly impossible, thanks to a bureaucratic maze, for the best-intentioned American soldier to marry, but of course, the War Department failed. Special relationships were as common as visits to the local pub. Al Spierling of Arroyo Grande, a B-17 flight engineer, lost a little of his youthful idealism—Spierling was a thoughtful young man who made a special trip to York to explore the setting for Brönte's *Wuthering Heights*—when he learned that a gunner he knew, a married man, had taken up with an English girl. He was a little shocked. "For a twenty-year-old," he said, "I learned a lot."[59]

There was the other special relationship, the one historian Keegan remembered, and that was with English children. Airmen seemed to have

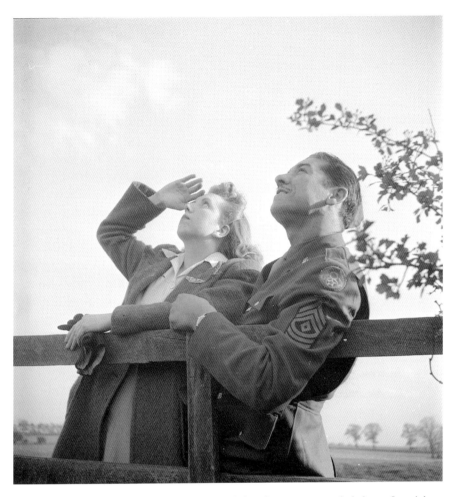

A young British woman and her airman watch bombers return to their base. *Imperial War Museum.*

great affection, just as Keegan's GIs did, for their smallest neighbors, and the affection was reciprocated. A typical sight at the beginning of any combat mission would be the childen gathered at an air base's perimeter fence. They were there to wave goodbye to the crews as their big airplanes took off to reach their assembly points high above the English countryside.

★ ★ ★

The odds against the airmen seeing those children again were formidable. In 1943, when Second Lieutenant Clair Abbott Tyler of Morro Bay left his 303rd Bomb Group's base at Molesworth on his last mission, he was a young man sacrificed to an appalling statistic: only one in five 8th Air Force crewmen would survive their twenty-five mandated combat missions (later thirty and then thirty-five) without being killed, wounded or captured. Another factor that may make Tyler's death even more painful was its seeming futility: the 303rd would complete, in 1943, repeated missions against the objective that cost Tyler his life—the U-boat base at Lorient—with little real impact on U-boat operations. By the time of Tyler's last mission, the 8th Air Force had dropped four thousand tons of bombs on Lorient but accomplished little more than the near-total destruction of the city—only three houses survived in a city of forty-five thousand. There was little damage to the sub pens themselves, which remained not only intact but also serviceable for French submarines after World War II had ended.[60] A far more decisive factor in ending the U-boat threat was the capture of the Engima machine and the subsequent breaking of the *Kriegsmarine*'s naval code by brilliant mathematicians and logicians like Bletchley Park's Alan Turing.

None of this would be known until after the war, but the focus on the sub pens was consistent with the American insistence on daylight precision

The Lorient U-boat pens in 2011. *Wikimedia.*

bombing aimed at targets of military value: infrastructure, aircraft production, factories, naval bases and refineries. Confident—overly so—in both the efficacy of the Norden bombsight and the defensive capability of the American bomber, the American command rejected the British model: nighttime "area bombing" of German targets intended to destroy German cities and their inhabitants' morale. In the later stages of the war, thanks in part to horrific losses among aircrews over strategic targets that were so fiercely defended, the Eighth Air Force would begin to adopt area bombing, as well. Despite the deaths of over 400,000 Germans, there is little evidence to suggest that civilian morale was damaged any more than the concrete sub pens at Lorient.[61]

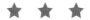

Two fliers from Arroyo Grande, copilot Clarence Henry "Hank" Ballagh and navigator Ed Horner, would demonstrate the American faith in technology that so encouraged the American commitment to daylight precision bombing. Both men would be members of B-17 "Pathfinder" crews, part of the 482nd Bomb Group stationed at RAF Alconbury, northwest of Cambridge. Their bombers were unique in their use of radar. Since the weather over northern Europe was so frequently cloudy, the chances were that any target assigned the 8th Air Force would be partly or completely obscured. Radar was to be the panacea for that problem. Planes like Ballagh's would employ a British radar system (a later American refinement was nicknamed "Mickey," after the mouse), housed in a bulb under the fuselage that replaced the ball turret. It was designed to penetrate cloud cover and facilitate precision bombing in almost any weather. Fliers like Ballagh and Horner, then, would lead bomber formations in over the aim point, locate it and fire a flare to signal the following bombers to release their loads. Because the radar-equipped planes, the "Pathfinders," were flying in the lead, they were, more than any other bombers, vulnerable to both flak and fighter attacks.

The new technology was work uniquely suited to First Lieutenant Ballagh. The valedictorian of his Arroyo Grande Union High School class, he had gone on to earn an engineering degree at UC Berkeley. His life accelerated rapidly after that. He'd enrolled in ROTC and so was commissioned a second lieutenant on the day of his graduation in May 1942. On May 23, he was sent to Florida for training. In July, a Bradenton County judge

officiated at the marriage of Ballagh and Frances Marie Hogan. The following March, Frances gave birth to a little girl, Enid—tragically, like Clair Abbott Tyler, Clarence Ballagh would be denied the chance to watch his daughter grow up.

When Enid was six months old, her father would, ironically, be killed in weather conditions his aircraft's technology was intended to overcome. Ballagh was not killed in combat. On September 14, 1943, he was instead seeking leave time in Edinburgh and had merely hitched a ride on another B-17, ominously named "Flaming Maybe." The bomber ran into thick weather and then into the side of Mount Skiddaw, in the Lake District, killing every man aboard. Fragments of the aircraft remain on the mountainside today. The impact was horrific: the airmen, once the wreckage was found, were identified by dog tags, wedding bands, laundry marks or the contents of their billfolds.[62] Ballagh was buried in a military cemetery in Brookwood, England, before being brought home to Arroyo Grande. He was a serious young man and had, before his death, sent money home to the United Methodist Church on Branch Street to be used for whatever purpose his church desired. That would turn out to be a new sidewalk, built by a group of parishioners that included Ballagh's father. It was dedicated in 1944 in a ceremony that included a moment when little Enid was invited to press her hands into the wet concrete.[63] The sidewalk is gone today.

The B-17 of another 482nd Bomb Group flier, also from Arroyo Grande, would be gone for over two decades. Second Lieutenant Ed Horner was the navigator on the Pathfinder "Crazy Horse," named for the great Lakota warrior, on February 21, 1944, when his ship ran into trouble. The bomber was headed for a target near Bremen during "Big Week," a series of missions intended less to destroy ground targets and more to use huge bomber formations as bait to draw enemy fighters into combat with their American counterparts. Flak hits damaged two engines, and the ship's pilot, twenty-six-year-old First Lieutenant Ralph Holcombe, had to drop out of formation, away from the protective firepower of the 482nd Bomb Group's massed machine guns, to try to make the run home to RAF Alconbury. "Crazy Horse," lumbering along on two engines, didn't make it. Over Holland, a German Focke-Wulf 190—the same type of aircraft that had ended Clair Abbott Tyler's life—made short work of the crippled bomber. Holcombe ordered the crew to "get the hell out!" while he fought to control the plane to give them the time to jump. He waited until it was too late; his body—he was the only crewman killed—washed ashore ten weeks after "Crazy Horse" plunged into the Ijsselmeer, an artifical lake northeast of Amsterdam.[64]

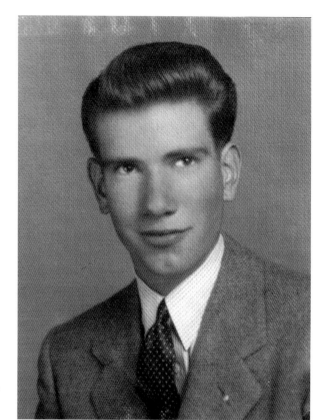

Right: First Lieutenant Clarence Ballagh as an engineering student at UC Berkeley. *Courtesy of the Ballagh family*

Below: Pathfinder B-17s, each with the telltale radar bulb on the underside of the fuselage, release their bombloads. *U.S. Air Force.*

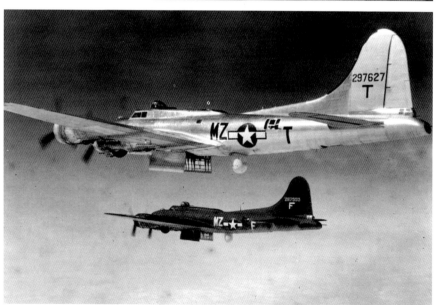

Three crew members, including future Santa Maria High School teacher and track coach coach Joel Punches, a second lieutenant and navigator, were sheltered by the Dutch Underground. Punches would be liberated in September. Ed Horner would spend the rest of the war as a POW at Stalag Luft I in Pomerania. Holcombe, a North Carolinian, was buried in the American Cemetery in Margraten, in the Netherlands. "Crazy Horse" would reappear during Dutch land reclamation efforts in 1970 when the wreck was revealed as the Ijsselmeer was drained. It was identified and salvaged by Dutch and American authorities.[65] When "Crazy Horse" had gone down on February 21, 1944, it had been only thirty minutes away from home.

It would be the Pathfinders that led the way, on March 4, 1944, in the Eighth Air Force's first daylight raid on Berlin. Another raid, on March 6, would go down in AAF memory as "Black Monday": 69 American bombers were lost in what was termed a "maximum effort" mission that involved an air fleet—814 bombers and 944 fighters—dispatched to Berlin by General Jimmy Doolittle, who had taken over command of the Eighth that January. The mission objectives were wartime factories in and around Berlin, but thanks to navigational errors, few of the bombers dropped their bombs on target, and one air division became separated from the other two, its isolation making it vulnerable to over 1,000 German fighters that took to the air in defense of the city. This was the mission on which Technical Sergeant Henry Hall of Cayucos, flying with the 91st Bomb Group, had seen the landing gear of a shot-up B-17 drop incongruously at twenty-five thousand feet preparatory to the final dive that claimed a pair of other bombers. He saw, too, a single American P-47 fighter take on a dozen German opponents over Holland's Zuider Zee, its pilot willing to sacrifice himself to protect the bombers under his care. (Hall would learn later that the American shot down 4 enemy aircraft that day.) Hall witnessed a bomber division that was supposed to be behind his go in ahead instead, thanks to the mistakes in navigation, and now in the van, that division paid a terrible price: one of its bomb groups, known ever after as the "Bloody 100th," lost 15 of the 16 B-17s that it had put up that day.

But it was the appearance of so many enemy fighters on these two missions that would lead Doolittle to order Arroyo Grande native Elliott Whitlock and his 96th Bomb Group to take part in a third mission to Berlin only three days later. By launching repeated raids with massive formations, Doolittle was using the same kind of tactics first attempted during "Big Week."[66] They were, in essence, the same attrition tactics that Ulysses Grant had used against Robert E. Lee in the last year of the Civil War. Grant latched onto Lee's army like a pit bull and refused to let go. The result was a horrific loss of men on both sides on a series of killing grounds from the Wilderness to Petersburg, but they were losses that Grant, with the North's superior population and industrial capacity, could afford to suffer. Lee could not. Fewer than thirty thousand of his starving Confederates remained to surrender at Appomattox Court House on April 9, 1865. Now Doolittle was hoping to winnow away the Luftwaffe and its cadre of veteran fighter pilots in the same way that Grant had used up the veterans of Lee's Army of Northern Virginia. Black Monday was a start: the losses that day had included 160 Luftwaffe fighter planes.

Mission briefing, Ninety-Sixth Bomb Group. *Roger Freeman Collection FRE 860 (Imperial War Museums).*

That meant that Whitlock's Ninety-Sixth Bomb Group, stationed at RAF Snetterton Heath, in Norfolk, would be part of Doolittle's bait on March 9, 1944. Whitlock, a grocer's son who played on the tennis team and acted in school plays at Arroyo Grande Union High School, was now the twenty-two-year-old copilot of a B-17 bound for Oranienburg, a Berlin suburb. Whitlock was by no means the most famous member of the bomb group. Neither was his pilot, First Lieutenant Jim Lamb. While many airmen kept dogs as pets—in the Ninety-First Bomb Group, for example, the bond between the young men and their pets became so powerful that a Ninety-First dog would telegraph, in his excitement, his recognition of the sound of his master's returning B-17[67]—the most famous member of the Ninety-Sixth may have been a pet donkey named Lady Moe. Another Ninety-Sixth flier, navigator Marshall Stelzriede, recalled that the donkey had come to Snetterton Heath in August 1943 as the guest of one aircrew on temporary duty in North Africa. They "obtained" the donkey from a farmer, made her an oxygen mask and flew her home, where she quickly became the group's pet. They dubbed her "Lady Moe, Queen of the Heath." The airmen also saw movies in the base's Lady Moe Theater and played ball on Lady Moe Field. Lieutenant Stelzriede remembered the group's mascot fifty years later:

> *She could always sense when it was chow time, and was invariably waiting outside the door of the mess hall at that time. One of the group's jokers would let her in the door and she would go right up to the serving table. Then the mess sergeant would take her out the door and feed her. She was the pet of everyone in the group.* [Lieutenant] *Miracle's crew made a blanket for her back, with the crew's name embroidered on it. When she couldn't get into a hut to lie near the stove, she would sleep in a tent that had been set up for her, along with two Dalmatian puppies that belonged to one of the officers. She was fed by everyone, and preferred candy and cookies to regular donkey food.*
>
> *Once* [copilot Second Lieutenant Thomas] *Dempsey gave her a stick of gum, and she chewed it without swallowing, looking very human in that respect. On a couple of occasions, Dempsey brought her into the hut and put her into someone's bed, under a blanket. Moe would sleep for hours, until the owner of the bed came back. Once, Dempsey acquired a pair of ladies' panties, cut a hole in the rear for her tail, and slipped them on Moe. She scampered up the walk to the officers' club, making a very comical sight. She often played around with the two Dalmatians. First she would chase them, then they would chase her. To escape from them, she would jump into a haystack.*

CENTRAL COAST AVIATORS IN WORLD WAR II

She finally got even with Dempsey. Whenever someone would tickle her flank, she would either try to bite the person or turn around and try to kick him. She was in our hut near the stove one evening when some of the boys were teasing her. This time Dempsey had his back turned and was bending over to tie his shoestrings when somebody tickled her. She reached out with both rear feet and let him have it on his backside. It almost seemed like she had a smile on her face as she left the hut.[68]

Despite the occasional indignities foisted on Moe by men like Dempsey, she grew very attached to the men of the Ninety-Sixth on her way to becoming famous—she was a special guest at the Army-Navy Game played in London in 1944—and by the time of Elliott Whitlock's Berlin mission on March 9, she would have been a regular fixture near the control tower at Snetterton Heath, where, on every mission, she waited quietly with the ground crews for the return of the Ninety-Sixth's B-17s.

There were 317 Eighth Air Force B-17s and 165 B-24 Liberators in the air that day, with an escort, in relays, of nearly 800 fighters. The losses this time were nowhere near those of "Black Monday," but one of them, set afire by flak over the target, should have been the B-17 flown by Jim Lamb and Elliott Whitlock. In a life that would be filled with many unselfish moments (Whitlock would someday get his law degree from USC and become known, during a career in the Palm Springs area, as a mentor and father figure to young attorneys), this was one of the young Arroyo Grandean's finest. Pilot Lamb attempted to put the fire in the cabin out, then returned to his seat to order his crew to bail out. The bombardier and navigator, just below the pilots, made the jump, but Whitlock saw no more parachutes. It was possible, he realized, that the fire had damaged the intercom system and the rest of the crew had not heard Lamb's order. He also noted that Lamb's hands had been

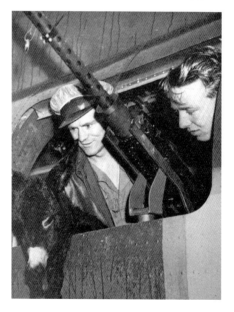

Lady Moe, the guest of the crew of the B-17 "The Miracle Tribe," arrives at RAF Snetterton Heath, the Ninety-Sixth's Bomb Group's base. *Museum of the U.S. Air Force.*

badly burned and that part of his parachute had been burned away. If the copilot jumped, the pilot was doomed.

Whitlock acted quickly. He countermanded the bailout order and turned to put the fire out (he vaguely remembered a fire extinguisher somehow appearing in his hands). With that under control, he dived the bomber in case the oxygen system had been compromised as well—the crew was as much in danger now from anoxia as from flak guns. He then bobbed and weaved, at low altitude, toward the English Channel. He called the radio operator forward, and between the two of them, they plotted the course back to Snetterton Heath, where B-17 #42-97524 and all souls aboard touched down where Lady Moe was waiting for them.

Second Lieutenant Daniel Elliott Whitlock of Arroyo Grande would win a Silver Star for bringing his ship safely home that day.

5
WAR IN THE PACIFIC

B-24 airman Albert Lee Findley Jr. considered himself blessed when he realized this his aircrew was being sent to Europe and not to the Pacific. That was the case for the vast majority of local fliers, who would do their flying over Germany, Austria or the Balkans. Findley might have counted his blessings even more—something he tends to do anyway—if he'd read the memoir of another veteran, former Santa Marian Roy Lee Grover, the pilot of a twin-engined B-25 Mitchell called "Tokyo Sleeper." Grover wound up, in late 1942, assigned to a base near Port Moresby, Papua New Guinea, and the men in his squadron learned quickly to respect the world that lay beyond the clearing that was their temporary home. When the flight engineer of another B-25 in Grover's 405th Bomb Squadron bailed out during an emergency, he landed a mile beyond the base airstrip on an island and in a tree that was infested with ants, which soon swarmed over the young American, who was immediately and frantically trying to clear them out of his clothing, ears and nose. He climbed down from the tree only to encounter a spider the size of a catcher's mitt, seemingly waiting for him in the center of its web. The airman used his .45-caliber pistol to kill the spider. It was a week before a rescue party of sympathetic locals got him off the island.[69]

Conditions remained primitive for Pacific fliers even near the end of the war. Far to the north, on Ie Shima, P-47 pilot John Sim Stuart, a retired Cal Poly architecture professor, flew in the last few weeks of World War II—in August, his squadron even witnessed the landing of a white Japanese "Betty"

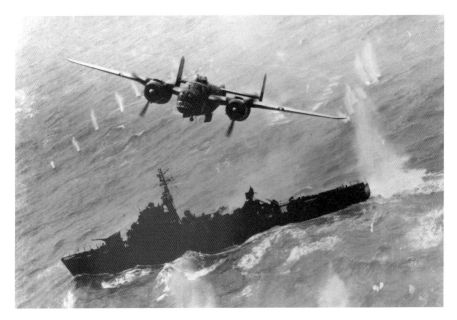

A B-25 Mitchell scores a near-hit—close enough to have inflicted damage—on the stern of a Japanese destroyer escort. *Museum of the U.S. Air Force.*

bomber as the Japanese peace delegation made its way to the Philippines. In the meantime, Stuart and his comrades lived, not in a barracks, but in two-man tents. Personal hygiene on the remote island became one of their first concerns. They handled the problem with American ingenuity: just outside their tents, a windmill provided the power to an agitator that punched and stirred their laundry in a tub full of soap and water; a fifty-gallon drum fitted with a spigot and mounted on a derrick was an effective shower.[70] Plumbing facilities were so important that at the officers' club at one New Guinea base, the lone flush toilet was not only functional but also valued for its attractiveness to guests, especially female—Red Cross girls and army nurses.[71] Health, especially in the Southwest Pacific, was precarious. A relentlessly depressing article in a 1946 issue of the *New England Journal of Medicine* lists, in descending order of cases, the most common diseases: diarrhea, malaria, hepatitis, dengue fever, hookworm, sand fly fever, scrub typhus and amoebic dysentery.[72]

The most constant companions of New Guinea fliers were mosquitoes. When another 405th flier defied regulations and went on a mission in shorts and a T-shirt, instead of the required long pants and long sleeves, he learned a terrible lesson. After he bailed out when his B-25 ran into trouble, he

disappeared for a few days. Another local rescue party brought him back to base, covered in mud, intended to soothe what was underneath: literally hundreds of mosquito bites on his exposed arms and legs. The man wound up terribly sick and was transferred out, presumably to an Australian hospital. The men of the 405th never saw him again.[73]

Pacific fliers, then, would have had little sympathy for the complaints of their comrades flying out of English bases. And although they didn't face the same dense flak and swarms of German fighters as those men, neither would they have had much sympathy for fliers who had to survive "only" twenty-five combat missions. In 1942–43, Roy Lee Grover flew fifty-seven missions, attacking Japanese shipping and airstrips and providing fire support for ground troops. But the courage of fliers in the two theaters of war was the same. So was their camaraderie and their collective irreverence toward army discipline. When they flew back to Australia after ferrying supplies and equipment to New Guinea, the tired and hungry aircrews of the 405th arrived at the Townsville Officers' Club at 4:45 p.m., ready for dinner, to be served at 5:00 p.m. They were greeted by an officious provost marshal who announced that all men without ties—that included Grover's comrades—would have to leave the club at dinnertime or be subject to arrest. That was an arbitrary and impractical dress regulation that did not sit well with Grover's young commanding officer, Major Ralph Cheli. When, at five o'clock, the provost marshal ordered his

P-47 Thunderbolts taxiing on the Ie Shima airfield. *U.S. Air Force.*

Central Coast Aviators in World War II

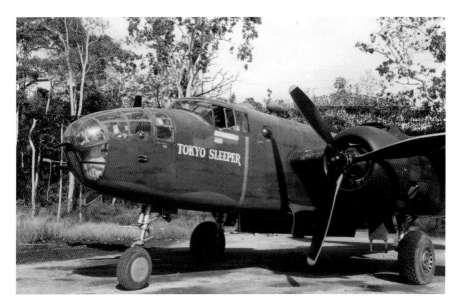

Roy Lee Grover's B-25, "Tokyo Sleeper." *U.S. Air Force.*

men out, Cheli cheerfully picked up a tray of glassware and threw it over the balcony of the club. His fliers followed suit with the club's furniture. They were duly arrested—at least, Cheli noted, it was for something they'd *done*—but were soon released by a sympathetic commanding officer, General Kenneth Walker.[74] They were needed to fight a war, not to wear ties.

Grover's experience with the two officers who demonstrated such empathy for their men was short-lived. General Walker, who insisted, despite his rank, on flying combat missions, was leading an attack on the Japanese stronghold of Rabaul a few weeks after the officers' club incident; his B-17 was hit and was last seen with one engine afire, surrounded by Japanese fighters. In August 1943, Major Cheli's B-25 was hit by fighters and set on fire during an attack on a Japanese base at Wewak, New Guinea. Cheli kept his plane on its bomb run, dropped his bombs and ordered his wingman to take over leadership of the squadron. He crash-landed into the sea and survived but was executed by the Japanese on Rabaul in March 1944. Both Walker and Cheli were awarded the Medal of Honor.

Roy Lee Grover's war, then, was one of near-constant discomfort relieved only by moments of audacity: the nimble and versatile B-25 Mitchell, the same plane seven Hancock Field graduates had flown from *Hornet* in the April 1942 Doolittle Raid, would bedevil the Japanese in the Southwest Pacific. Major Cheli was among the men who perfected skip-bombing

techniques that would wreak havoc on Japanese shipping. Another of Grover's acquaintances was "Pappy" Gunn, a forty-two-year-old lieutenant colonel, frequently described as "a wild man," who hated the Japanese because his wife and children were their prisoners in Manila and hated military bureaucracy because its glacial pace got in the way of his seeing them again—a reunion that could only come with victory. A self-taught engineer, Gunn tinkered constantly with the Mitchell and, in the process, turned it into a true killing machine. Gunn, named appropriately, boosted the bomber's forward Browning machine guns from two to four and the waist guns from single to double batteries, making the B-25 lethal beyond its designers' wildest dreams.[75]

Grover would push his Mitchell, "Tokyo Sleeper," to its limits in another attack on Japanese forces at Wewak, New Guinea, on September 2, 1943, when he led an eight-plane formation in an attack on two cargo ships at anchor. Grover dropped two bombs on one of the vessels, and one of them detonated at the waterline, setting the ship afire, a hit attributable to "Tokyo Sleeper's" altitude. Grover had flown his Mitchell so low that the cargo ship's radio antenna was later found draped around one wing. Eight Japanese fighters then appeared and swarmed over Grover and his wingman, Lieutenant Charles Barber. Lieutenant Barber's B-25 was hit and plummeted into the sea. Grover dove sharply, zigzagging just above the wave crests, periodically turning "Sleeper" to give the man at the powerful forward guns and the top turret gunner clear shots at the Japanese fighters. His gunners shot down two of them. The enemy fighters, low on fuel, finally gave up the chase, and "Tokyo Sleeper," riddled with bullet holes but mostly intact, made it home.[76]

Something of Grover's B-25 unit's audacity crept into the heavy bomber groups—overwhelmingly made up of men who flew B-24 Liberators—in the Southwest Pacific, as well. One of the most famed units painted the skull and twin bombs as crossbones on their tail assemblies and called themselves the "Jolly Rogers." The name was a tribute to the Ninetieth Bomb Group's dynamic commanding officer, a young Colonel Art Rogers, who embellished his Errol Flynn mustache by turning it upward at the corners. Rogers, commander of the Ninetieth in New Guinea in 1942–43, left the bomb group with an élan that would serve it throughout the war, and the Jolly Rogers would be credited with the destruction of 126 enemy aircraft and over 200 ships and boats—ranging from freighters to destroyers to small coastal craft—during the unit's time in the South Pacific.[77]

One of the Ninetieth's copilots was from San Luis Obispo, and he did not survive the war. Second Lieutenant Nicholas Covell wasn't

buccaneering on his last mission; the Liberators were instead preparing Peleliu for its eventual invasion by the marines who would fight a horrific two-month campaign—appropriately named "Operation Stalemate"—to secure the island. After their June 11, 1944 mission, a raid on the Japanese airstrip on Peleliu, Covell and his crew were evacuating wounded men from another Liberator when theirs crashed and burned short of the landing strip on Hollandia. There were only four survivors.[78] Another San Luis Obispo B-24 copilot, Second Lieutenant Ted Lee, was a talented musician—a trombonist—who'd organized his own band while in flight training. He earned his wings in Arizona, became a flight instructor at Minter Field in Shafter and then shipped out to a combat tour that ended on December 5, 1944, when his Liberator was shot down near Noemfoor Island, in the Dutch East Indies. It was far away from home for an aviator whose life ended so soon; Ted Lee, only twenty years old, died eight thousand miles away from the California coast.[79]

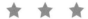

The scale of the Pacific war beggars the imagination: at about the time Nicholas Covell lost his life on Hollandia, B-29 gunner Sergeant John Sanderson Gibson's 468th Bomb Group was fighting its air war from a base near Kharagpur, West Bengal, 6,700 miles to the northwest. This was officially called the China-Burma-India (CBI) theater, and the bombers the AAF employed here, beginning in 1944, represented a new generation of aircraft intended to conquer both distance and the Japanese home islands. The B-29 Superfortress was twenty-five feet longer than the B-17—its wingspan wider by over thirty-five feet—and it was faster than the B-17 by nearly eighty miles an hour. At 105,000 pounds, it nearly doubled the B-17's gross weight, and most important for the missions the newer bomber would undertake, its range of 5,800 miles meant that it was suited for the vastness of the war in the Pacific.[80] For the Superfortress's aircrew, the most important difference meant that the cabin of the big plane was pressurized: at high altitude, they had no need for the bulky flying suits or oxygen masks of their counterparts fighting in the European theater.

But Gibson's trip to the CBI theater, in April 1944, was something of an ordeal. It took Gibson, a longtime Cambria resident, and his nine crewmates nine days to reach their base, northwest of Calcutta, flying at night to allow the navigator to use the stars to plot their route from Salina, Kansas, to

"Gone with the Wind," the first B-29 to arrive in the CBI Theater, touches down in India. *Museum of the U.S. Air Force.*

Dayton, Ohio, Prescott, Maine, Gander, Newfoundland, and then across the Atlantic to Marrakesh, Morocco (120 degrees in the shade, Gibson remembered), to Cairo, and, finally, to Kharagpur.

If conditions in the Southwest Pacific were primitive, fliers in the CBI theater were in some ways even worse off; they were so isolated that each man on Gibson's B-29 also doubled in maintenance—Gibson was responsible for the automated central fire control systems—and some planes doubled as cargo planes. They would be stripped of armament, except for the tail guns, and loaded with gasoline drums and other supplies that would be ferried to the squadron's forward base in China. It was six weeks before the 468th had stockpiled enough supplies at its forward base and so was ready for the first B-29 mission that would strike at Japan itself.

The mission targeted the Imperial Steel Works on the southernmost Japanese home island, Kyushu. Searchlights probed the sky for the big American airplanes—"the first time in my flying career," Gibson remembered, "that I kicked myself and asked, 'Jack, did I really ask for this?'" Each plane dropped its bombload individually—the carefully

planned geometric formations of the Eighth Air Force in Europe were too sophisticated for these pioneering B-29 groups, so Gibson can be forgiven for believing that Japanese ground gunners were singling out his Superfortress, because they probably were. For the next nine months, Gibson flew seventeen more missions—one lasted over eighteen hours—against targets in Japan, including Nagasaki and Yawata—and elsewhere, over Shanghai and, finally, Burma and in Singapore, where, in March 1945, his B-29 was shot down. His crew floated, for twenty-four hours, in their individual life rafts in the Straits of Malacca before they saw a distant naval vessel. Their hopes were dashed twice when the little ship passed them by without seeing them. That was nothing to compare to the disappointment that came when the boat finally found them and plucked them out of the water.

It was a Japanese patrol boat.[81]

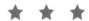

The B-29 was, at first, a seeming burden on the U.S. Army Air Forces. In early models, the powerful engines were prone to overheating, and the result could be catastrophic wing fires. Famed test pilot Eddie Allen and his crew had died after an engine fire doomed his prototype B-29 in a 1943 flight over Boeing Field. Another hazard early on in the plane's development was one that endangered the big ship's gunners: the Plexiglas blisters sometimes blew out when the cabin was pressurized, necessitating a precautionary restraining strap to keep the gunner inside the airplane.[82] The problems became more manageable as ground crews learned to deal with the aircraft, but mechanical problems remained as big an obstacle to the B-29s as Japanese fighters or flak.

Captain Jack Nilsson of San Luis Obispo would become a B-29 pilot with the 498th Bomb Group in the western Pacific. The 498th was one of the bomb groups stationed in the Marianas, an island group that included Saipan, Tinian and Guam, taken by the U.S. Marines, who suffered three thousand men killed, in the summer of 1944. Saipan was perhaps most notorious for the sight that confronted horrified marines as they began to overrun the island's defenders: Japanese civilians, convinced by propaganda that they would be tortured by the Americans, leaped to their deaths from the island's cliffs into the sea. Within months, their counterparts on the Japanese home islands would face unimaginable terror inflicted by new B-29 units flying out of the Marianas.

Jack Nilsson was a small-town boy from San Luis Obispo, and 1931, when he was in sixth grade, would have been one of the busiest years of his young life. He and his class at the Frémont School toured the printing plant and editorial offices of the *San Luis Obispo Telegram-Tribune*, enthralled, no doubt by the Rube Goldberg array of pneumatic tubes that reporters used to shoot their copy, ripped out of the typewriter and rolled into cylinders, that were inhaled and shunted downstairs to Composing. He was invited to Patsy Berkemeyer's sixth birthday party, one that was presumably unforgettable because the Berkemeyers were bakers and would have spared no expense on Patsy's birthday cake. In June, he was promoted to junior high school; his graduating class there three years later would include Alex Madonna, later famed for his Madonna Inn, who would someday become lost flier Clair Abbott Tyler's best man. In high school, Nilsson discovered a talent for rifle shooting and would compete successfully against other teenagers. He was apparently popular, because his attendance is noted at several 1930s dance parties, at the Fish family's home, then the Austins' and then the Lauritsons'. Like many local boys, he would go on to Cal Poly, majoring in animal husbandry, and his shorthorn steer would win an award at a Los Angeles stock show. By 1940, he had been bitten by the flying bug and completed the civil aeronautics course advertised by the Hoover brothers and Earl Thomson at the county airport.[83] Four years later, at twenty-five, he was a B-29 pilot in the 875th Bomb Squadron of the 498th Bomb Group, whose original mission was similar to that of air groups in Europe: high-level precision bombing aimed at military targets and infrastructure in Japan.

The early missions of the B-29s flying out of the Marianas were no more successful than the problematic test flights that had typified the bombers' development, and that failure would eventually lead to the tactics that would cost Jack Nilsson his life. The B-29s continued to be plagued by mechanical problems, by targets that were obscured by cloud cover and by the westerly jet stream, so powerful that it broke up the bomber formations long before they could reach their targets in Japan, which remained mostly intact: eleven raids on the Nakajima plant in Musashi, an important producer of aircraft, destroyed only an estimated 10 percent of the factory complex at the cost of forty B-29s.[84] The results dismayed both President Roosevelt and the U.S. Army Air Forces commander, Hap Arnold, who had taken personal command of the B-29 fleet, designated the Twentieth Air Force. Arnold was determined to prove that Japan could be defeated by airpower alone. His bombers, he believed, would eliminate the need for an invasion, which, after the horrific examples of two 1945 battles, Iwo Jima and Okinawa, would mean casualties

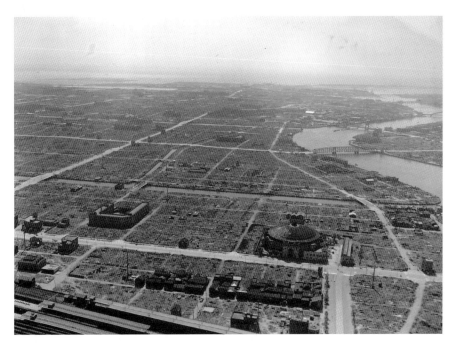

Postwar Tokyo demonstrates the horrific impact of incendiary bombing. *U.S. Army Signal Corps.*

beyond Americans' imaginations. Arnold's motivations were political as much as strategic: he also wanted to use the B-29 to establish the justification for the postwar creation of the U.S. Air Force as an independent service branch.[85]

That meant that, in January 1945, thanks to an increasingly concerned Hap Arnold, Nilsson would have a new, more aggressive commander. That officer was a soft-spoken but hard-driving Eighth Air Force veteran, one of the most controversial military officers in American history, General Curtis LeMay. In March, LeMay would unleash a new B-29 campaign on Japan that resembled British and American tactics against Germany: nighttime raids on cities, using a mixture of high-explosive and incendiary bombs that would prove to be incredibly destructive. To improve his bombers' accuracy, LeMay ordered attacks at much lower altitudes. The lethal new tactics, used in a March firebombing of Tokyo, may have taken as many as 100,000 lives in a raid that was deadlier than either of the atomic bomb missions flown five months later. The low-level attacks also meant, of course, that American losses would mount. LeMay countered by ordering more missions to more cities. The remorseless pace, intended to drive Japan to its knees, was near a crescendo on the night of May 23,

1945, when Nilsson's B-29 flew on an incendiary raid on southern Tokyo, between Kawasaki and the Imperial Palace.

They would meet heavy resistance. William C. Atkinson, a twenty-year-old navigator in Nilsson's 498th Bomb Group, recorded his impressions of that night as his ship approached its bomb run:

> *Flak could be heard now. That meant it was close. It sounded like sheets of tin, big ones, being snapped. The bursts not quite so close were like* [heavy boots] *being dropped on the floor of the apartment above. I could see the glow of the fires below on the fixtures in the blisters....Ground-to-air rockets were arcing upwards in white, fiery pursuit of the ship behind us. The fires cast a redness on the sky. Individual blocks and streets could be seen burning and elsewhere whole masses of city blocks were afire in sections with right-angled corners like the black spaces in a crossword puzzle. We had just flown through the smoke, rough like a cumulus cloud, and its acrid odor lingered in the plane.*[86]

The crewmen of Atkinson's B-29 breathed a sigh of relief when they reached the clear air and relative safety of Tokyo Bay. They'd left behind the B-29 piloted by Jack Nilsson, shot down over Tokyo. There were no survivors.

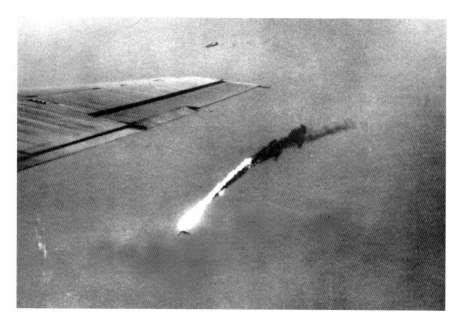

A B-29 in flames over Japan. *U.S. Air Force.*

6

LOSSES

AL SPIERLING'S "EPITAPH" in his 1940 high school yearbook was revelatory:

Over a motor he will often pose,
Experimenting, Tormenting,
On thru life he goes.

After the nation went to war in 1941, the U.S. Army Air Forces' battery of aptitude tests quickly uncovered the young Pennsylvanian's gift for mechanics. He would go to engineering school in Amarillo, Texas, and emerge as a flight engineer and top turret gunner in the 8th Air Force, 457th Bomb Group, stationed at RAF Glatton in East Anglia, in early 1944.

Technical Sergeant Spierling kept a log of his missions. One of the most memorable missions was the unlucky thirteenth, over Berlin in the spring of 1944. As the squadron began its bomb run, turbulence caused the B-17 above Spierling's to drop so close to his ship, "Georgia Peach," that he could count, watching transfixed from his top turret, the rivets on its bomb bay doors. The other ship sheared off part of "Georgia Peach's" tail, then it dropped its bombload. Somehow, the bombs missed, and "Peach" kept flying. But more trouble came with the trip home.

A German 88-millimeter antiaircraft shellburst perforated the fuselage next to Spierling and just behind the pilots' seats. It left a gaping hole. Spierling was okay. The plane was not. Flak from the exploding shell had severed the throttle cables to both engines, Numbers One and Two, on the

Central Coast Aviators in World War II

Left: Al Spierling poses next to his top gun turret position. *Courtesy of the Spierling family.*

Below: Al Spierling's "Georgia Peach," with its damaged tail, makes it home from a mission over Berlin. *Roger Freeman Collection FRE 8360 (Imperial War Museums).*

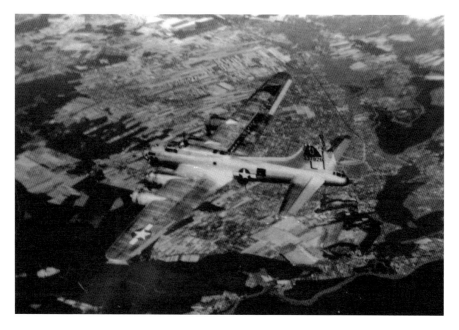

left wing. "Peach" began descending from twenty-two thousand feet typical of the squadron's missions; it was rapidly hemorrhaging altitude when it approached the edge of the continent and the North Sea. When the B-17 was one thousand feet above the water, the pilot, First Lieutenant William Clarkson, yelled "Al! Get me some power! NOW!"

As soon as Lieutenant Clarkson bellowed for more power, Spierling understood what had happened. He said many years later that this was because of eighteen weeks of training at Amarillo, but it was his intuition—he had an inborn and uncanny mechanical gift—that led to what happened next. He wiggled beneath the pilots' seats, crawled into the bombardier's station and found the two severed cables. He gave them a yank. The B-17 was now two hundred feet above the water and the kind of water landing—the North Sea's surface was no more forgiving than concrete—that often proved fatal to American aircrews.

The engines restarted.

P-51B Mustangs prepare to take off on a mission from their base in England. This new fighter would change the course of the air war in Europe. *Museum of the U.S. Air Force.*

"Peach" made it home safely. Spierling, a smoker then, emerged from the airplane and couldn't get the cellophane off his pack of cigarettes because his hands were shaking so badly. He would win a Distinguished Flying Cross. He had just turned twenty-one but had twenty-two more missions to fly.[87]

Spierling would survive them to come home, get a bachelor's degree at UC Santa Barbara, start a family, get his master's at Cal Poly and become a longtime fixture at Arroyo Grande High School as the auto shop teacher. Spierling wasn't "just" a shop teacher. He would become the real founder of the excellent vocational education program at Arroyo Grande High School and prove to be a gifted administrator. After retirement, he worked as a docent at the Paulding History House in Arroyo Grande and was a go-to problem solver in his part-time job at Miner's Hardware. But his passion was teaching students about engines. His students loved him, loved his integrity, his patience and his knowledge, and they caught Mr. Spierling's passion. Many of them say that he was their favorite teacher in high school.

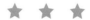

The bomber campaign in Europe acquired a new focus in May 1944. One key to the defeat of Nazi Germany lay, ironically, in the success of the *blitzkrieg*, the mechanized war that had resulted in such quick victories in Poland in 1939 and in the Low Countries and France in 1940. Blitzkrieg, with its coordinated use of aircraft, tanks and trucks, required the one resource Germany lacked: oil. For Eighth Air Force crewman Bob Brown, a San Luis Obispo veteran of RAF Snetterton Heath's Ninety-Sixth Bomb Group, that meant missions that included repeat visits to Meresburg, Germany, and its oil refineries; for the Fifteenth Air Force's Jess Milo McChesney, flying out of Italy, a frequent target was the Moosbierbaum refinery complex near Vienna.[88]

It was the Fifteenth Air Force that had demonstrated, earlier in the war, both the hazards and the rewards of targeting enemy oil resources. A low-level 1943 raid on the Ploesti oil refineries in Romania, heavily defended by both flak guns and fighters, had cost fifty-three bombers. Although the oil complex was seriously damaged, repairs were made within weeks, so German oil supplies from Ploesti were only temporarily interrupted. Still, by 1944, the raid on Ploesti (repeated raids would begin to disrupt production there) may have been a template for General Carl "Tooey" Spaatz's

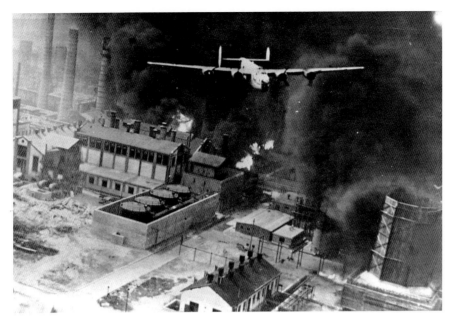

A B-24 Liberator, at near-rooftop level, in a raid on the Ploesti oil refinery complex. *Museum of the U.S. Air Force.*

oil campaign, beginning in 1944. Spaatz commanded the Americans' strategic bombing force in Europe—including both the Eighth and the Fifteenth Air Forces—and would fight to make oil production the priority for his bombers. Spaatz's thinking was inescapably logical: his top priority, according to the Allied command, wasn't oil. It was instead the destruction of the Luftwaffe. But by sending fliers like Brown and McChesney after oil refineries and the rail hubs that transported oil, Spaatz would deprive the Luftwaffe of fuel and, in the process, draw their fighters into the air. Once again, the bombers were to be both offensive weapons and the bait that German fighter pilots could not resist.[89]

Al Spierling's missions would also include oil facilities at Hamburg and at Ruhland (and another, infamous site: the ball-bearing factory complex at Schweinfurt, where, in October 1943, the 8th had lost sixty bombers), and General Arnold had been right: the fighters came up after the 457th Bomb Group's B-17s. But by the time of Spierling's mission over Ruhland in 1944, the bombers had as escorts the powerful, nimble P-51 Mustangs, with wing tanks giving them the range earlier fighters didn't have, and Spierling watched, amazed, as four Mustangs sped toward a formation of

more than thirty Messerschmitt 109s and broke them up. The German fighters reappeared on the 457th's homeward leg—"We got bounced," Spierling remembered—but the Mustangs reappeared, too, and the B-17 crewmen watched what turned into the airborne equivalent of a barroom brawl. Spierling never forgot the German pilot he saw, crawling out of the cockpit of his doomed FW-190. The Luftwaffe flier was wearing a yellow flying scarf that flew straight out, and his parachute was on fire. The young American watched the beginning of the young German's fatal fall to earth.[90]

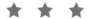

Harold Schuchardt was the Fifteenth Air Force copilot who, early in his combat tour, survived a harrowing landing on a short Corsican airstrip that was a tribute to the skill of his pilot. With an engine from their B-17 damaged and what was literally a junkyard of wrecked bombers just beyond the airstrip, Schuchardt, who, like Spierling, had a mechanic's gifts, pulled a cylinder head from a wrecked B-17 and replaced the damaged part on his crew's ship. While he salvaged some replacement fuses, the crew siphoned enough oil out of the wrecks to replenish their plane's levels and hung on as their pilot, in another masterful performance, lifted off the Corsican airstrip and got them back to base in Italy.

Schuchardt remembered Italy fondly, entranced, when on leave, by its beauty and by its people. When exploring a new town, he made it a habit to check in at the local police station, where, invariably, at least one policeman would invite him home for dinner. "I spent many nights in Italian homes eating their spaghetti, drinking their wine, and sleeping in big feather beds in huge old homes," he recalled in a 2007 interview.

When he went back on duty, Schuchardt became the pilot of his own plane, and his thirteenth mission would turn out to be even unluckier than Al Spierling's. He was stunned to hear the mission announced in advance over Armed Services Radio; Schuchardt and his crew were endangered by a thoughtless public relations broadcast that let the enemy know that this would be the Ninety-Seventh Bomb Group's 300th mission. The Luftwaffe was waiting for them on July 2, 1944, over Hungary.

Once the German fighters—FW-190s, Me-109s and the twin-engined Me-110s—found the Ninety-Seventh, a rapid sequence of events doomed

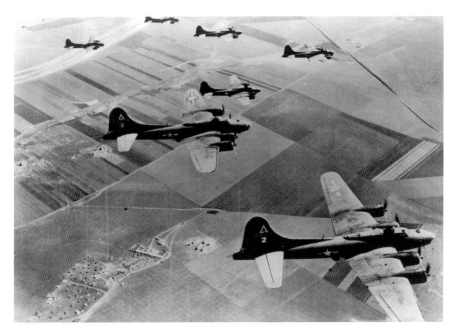

A flight of Fifteenth Air Force B-17s on its way to the beaches at Anzio, Italy. The plane at the bottom of the photo, serial no. 42-30056, was the bomber piloted by Harold Schuchardt when it was shot down on July 2, 1944. *Roger Freeman Collection, FRE 10136 (Imperial War Museums).*

Schuchardt's B-17. The fighters attacked his ship when it was most vulnerable, on its bomb run, when the plane had to fly straight and level. The first hit was on the Number Four engine, on the right wing, which caught on fire. The crew watched as fighter after fighter passed them: "I could feel they were hitting different surfaces and wires," Schuchardt remembered. "I could feel I was starting to lose control. Then they hit the left wing." That's when Schuchardt, sensing that the bomber was about to go into its death roll, gave the bailout order. He went out after the instrument panel exploded in front of him. Eight of the ten men made it to earth; the tail-gunner didn't, and neither did one waist gunner, a big, strong Missouri farm boy. His crewmen later told Schuchardt that the waist gunner was helping the others get out, assuring them he'd be out right after them.

Schuchardt guessed that he bailed out at about eighteen thousand feet, and he was twisting violently as he fell. He pulled his ripcord just before blacking out, then landed in a muddy cornfield, where his wristwatch came flying off and he lost a boot. He looked up to see a crowd of villagers approaching, one of them with a gun, others with pitchforks. They began

leading him to the village, spitting on him and jabbing him with the implements—Schuchardt had wisely opted not to carry his .45 pistol that day because it might only encourage violence, if he were to be shot down, on the part of the Hungarian civilians, who were frequently the victims of the American air raids. He found, once they'd marched him to the village, his radioman, his face covered in blood from a horrific skull fracture. He managed to wet his handkerchief and wipe the man's face. The radioman asked Schuchardt to hear his confession, but the villagers pulled the pilot away and began to beat him at a nearby schoolhouse.

A truckload of German soldiers then arrived in the village. The Germans jumped down from the truck and saved Harold Schuchardt's life.[91]

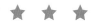

Al Findley was the B-24 Liberator radioman who had the distinction of being shot down on his first combat mission. Luckily for him, his pilot, fellow Oklahoman Byron Johnson, was as talented as Schuchardt's had been, and he brought the bomber down near a French town in Champagne, Epernay, that had just been liberated by the Allies. The good people of Epernay were delighted with their unexpected guests, and like Schuchardt's Italians, they insisted on wining and dining the young Americans—one of the villagers, Jean-Louis, became pen pals with Findley's mother back in Oklahoma. The good times lasted for a week, when their squadron commander buzzed Epernay and dropped a testy message: Lieutenant Johnson and his crew were to report to Reims immediately and hitch a ride on an Army C-47 back to base in Attlebridge.[92] The second shootdown, over Germany, would lack the first one's charms.

The dairyman's son, Jess Milo McChesney of Corbett Canyon, came close to matching Findley's dubious honor—that of being shot down on his first mission. McChesney's overseas assignment took him to the 376th Bomb Group, the "Liberandos." Originally stationed in North Africa, the 376th, which had participated in the costly raids on the Ploesti oil complex, was now based at San Pancrazio, Italy, southwest of Florence. On McChesney's first mission, the target was the Vosendorf oil refinery near Vienna, and McChesney's B-24 was hit by a flak burst when it was at its most vulnerable: during its bomb run, again, when the plane had to be held straight and

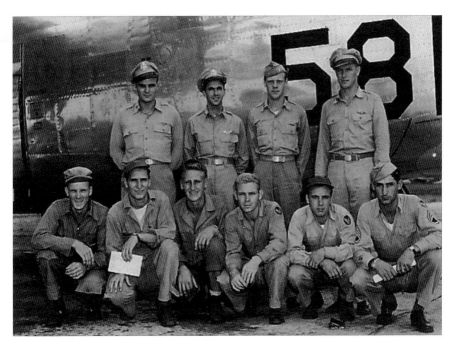

Captain Jess McChesney, Fifteenth Air Force (*top right*) and his B-24 crew. *Courtesy of Michael McChesney.*

steady to ensure the accuracy of the bomb drop. A flak gun found it instead; one engine was destroyed, and the aircraft's wings were riddled with holes. McChesney kept the plane on its bomb run, released the load and made a run for home with his crew throwing out everything nonessential—including their guns—to keep the plane in the air. Luckily for McChesney and his men, a lone P-38 fighter shepherded them to an emergency airstrip in Italy, where, without brakes or an instrument panel, destroyed in a cockpit fire, with only limited hydraulics, Jess McChesney put his airplane down safely.[93] Family tradition has it that McChesney had to make a belly landing on his last mission as well, on a British airfield, and that he brought that one off with only one crewman seriously injured. One of his gunners looked up McChesney through his family many years after the war and was sad to learn that his pilot had died. "I would fly to the gates of hell with that man," he said simply.[94]

If there is a local record for narrow escapes, it belongs to Peder Heller of Arroyo Grande, the longtime owner of Heller's Boat Shop. Heller was a Liberator flier in the Ninety-Third Bomb Group who was shot

down *three* times. Heller's nickname was "Lucky," for reasons that are self-evident. *San Luis Obispo Tribune* reporter Carol Roberts profiled Heller before his death in 1996, a death that should have come in 1944. Heller was the tail gunner on a B-24, badly shot up by flak over Germany, when he fell asleep as the plane fought to get home. Normally, on takeoffs and landings, the gunners gathered in the center of the fuselage to make the plane easier to handle. No one summoned the sleeping Heller: when the bomber hit the airstrip hard, the tail section, with Heller at his guns, snapped off. The rest of the airplane exploded, killing every other crewman.

It happened again. Reporter Roberts described Heller's next escape:

About three weeks after the first crash, Heller was part of a bombing raid on some Nazi railroad yards about 60 miles south of Paris.

His B-24 had been shot up. Two of its engines were out completely and the other two were running poorly. It was flying "on the deck" skimming over the English Channel when all the engines quit.

"As the plane came down, I climbed up into the waist window, which wasn't standard ditching procedure. I had an arm and both feet out the window when we hit the water. I went flying."

Heller sank beneath the sea, then released his "Mae West" life jacket on the way back up.

When he surfaced, he saw the plane hit some rocks and explode. Everyone aboard was killed.

"I started to swim then realized the water was only waist-deep and walked to shore."

And it happened again. Heller's B-24 didn't even get into the air the third time: a tire blew on takeoff, the plane's nose dipped, a wing tank ruptured and a planeload of aviation gasoline ignited. Heller—this time at his takeoff station in the fuselage—pushed a crewmate out the waist, followed him and began to run for his life. When the Liberator's bombs began to explode, he realized he was the only airman who had *kept* running. The rest of the crew stopped and watched, from about fifty feet away, as their B-24 burned. The detonation of the bombs killed all of them.

Heller would be credited with five kills of enemy fighters, including two Focke-Wulf 190s, and win the Distinguished Flying Cross with an Oak Leaf Cluster and an Air Medal. When Roberts interviewed Heller in 1990, he'd hidden the medals away. He'd survived harrowing adventures but never talked much about the medals.[95]

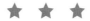

No aviators talked much about what was happening five miles below them. The Norden bombsight wasn't nearly as effective as it had originally been billed. Neither was the Pathfinders' radar, which tended to work only where a target bordered a large body of water. This meant that civilians were dying—in great numbers—and they died in terror. The determination to shut off Germany's supply of fuel in 1944–45 meant the 8th and 15th Air Forces also launched repeated attacks on the rail system that transported fuel and especially on rail yards—for Jess McChesney, the targets of at least half his thirty-five missions. The Americans knew that working-class housing bordered the rail yards, so those neighborhoods were frequently destroyed by their bombs. The superb World War II historian John McManus captured the anguish felt by Jim Lynch, a radio operator in the 379th Bomb Group:

> *I know that our entire crew despises every mission we fly. We are aware that we may be killing innocent civilians. We know it does happen. That makes it more difficult with each passing day to fly the next mission. Long after this war is over, we know we will have to live with our consciences. We may try to stuff awareness into our subconscious, but it will always be lurking there waiting for something to trigger it, such as the plaintive crying of a little child.*[96]

What they had to hide from themselves would become increasingly horrific as the air campaign accelerated in the final months of the war against Germany and as the AAF seemed to increasingly adopt the "area bombing" strategy Sir Arthur "Bomber" Harris, head of the British strategic bombing forces, had been advocating for years. The British, for example, had hit Hamburg in 1943, dropping a mixture of explosive and incendiary bombs, generating fires that killed thirty-five thousand people. The victims of the European war's most notorious bombing, in February 1945, were the people of Dresden, one of the most beautiful cities in Europe, attacked by waves of American and British bombers. A British prisoner of war in Dresden, Victor Gregg (An American POW in the city, Kurt Vonnegut, was spared from death inside the shelter of Slaughterhouse-Five), still dealt with what he'd witnessed seventy years later:

> *At about 10.30 pm that night, the air raid sirens started their mournful wailing and because this happened every night no notice was taken. The*

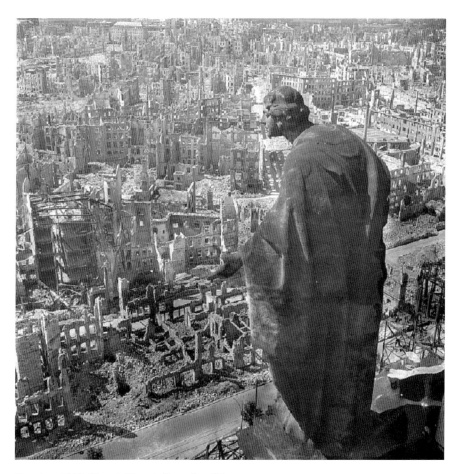

Dresden, 1945. *Deutsch Phototek, Saxon State Library.*

people of Dresden believed that as long as the Luftwaffe kept away from Oxford, Dresden would be spared. The sirens stopped and after a short period of silence the first wave of pathfinders were over the city dropping their target flares.

As the incendiaries fell, the phosphorus clung to the bodies of those below, turning them into human torches. The screaming of those who were being burned alive was added to the cries of those not yet hit. There was no need for flares to lead the second wave of bombers to their target, as the whole city had become a gigantic torch. It must have been visible to the pilots from a hundred miles away. Dresden had no defences, no anti-aircraft guns, no searchlights, nothing.[97]

Scholars still argue over the death toll that February, with recent estimates ranging from 18,000 to 25,000, while others have argued the number of dead may have approached 100,000. But civilians weren't the only victims of the heavy bombers. On July 24 and July 25, 1944, Al Spierling's crew flew two missions, carrying fragmentation bombs, near St. Lo, France. That was where the Germans fighting to hold on to Normandy had blunted the American advance, and the Americans' ground commander, Omar Bradley, was determined to break out of the hedgerow country and into the road net that would uncover Paris. Bradley decided to use the heavy bombers of the Eighth Air Force to pulverize the German lines, and the air operations did just that: the German infantrymen who survived emerged from their trenches dazed, disoriented and bleeding at nose and ears from the concussions of the heavies' bombloads. But the bombs began falling on the Americans as well. Before the bombardment lifted, the Eighth and Ninth Air Forces had killed over one hundred Americans, including Lieutenant General Lesley McNair. Bradley was furious, and so was the Eighth's commander, James

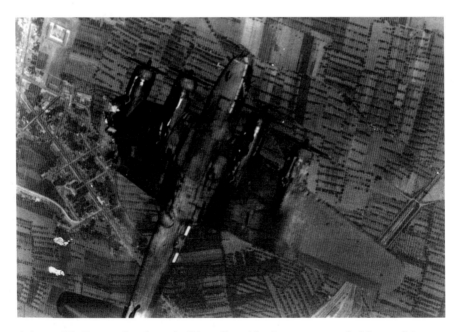

A doomed B-17, one wing sheared off by a direct hit, plummets to earth. *Museum of the United States Air Force.*

Doolittle, but armored columns pushed forward by American general Joe Collins penetrated the shattered German lines.[98] It was a victory tarred by a tragic mistake.

The knowledge of what they'd done, no matter how unintended it had been or how far removed they'd been, would haunt many veterans for years after the war had ended. Randall Jarrell, an AAF navigation instructor, would publish five volumes of his poetry in peacetime, but he is remembered most for a single, haunting, antiwar poem, "Death of the Ball Turret Gunner." It has had a powerful impact on generations of American high-school students who never knew the war years. Mercurial, sometimes acid, but passionate in his humanity, Jarrell's life began a downward spiral after the death of his World War II cohort John F. Kennedy. Friends reported that in the days after Dallas, the poet sat in anguish, weeping and inconsolable, in front of his television set. In 1965, near Chapel Hill, North Carolina, the fifty-one-year-old teacher and man of letters was struck and killed by a car on Highway 15-501. The poet's death was ruled an accident, but many of his contemporaries, including the poet Robert Lowell, didn't believe it. In a way, what happened may have been Jarrell's final mission. The distraught driver insisted that the poet had walked deliberately out of the dusk and into the path of the car.[99]

7

"FOR YOU, THE WAR IS OVER"

The second time B-24 radioman Al Findley was shot down, in February 1945, was on his twenty-sixth mission. The target was Magdeburg, a city once famed for Martin Luther's preaching but now important to the German war effort for its production of synthetic fuel from lignite coal, integral to Spaatz's "oil campaign." Findley's bomber had released its payload and was on its way home, over the Ruhr Valley, when it was hit by flak bursts on the tail and on the left wing. Three gunners were injured. Control cables were severed. The pilot ordered Findley and the uninjured aircrew to throw out everything that was loose to lighten the load, but the radioman realized how serious the situation was when he saw the copilot putting on his parachute. "Bail out!" he yelled at Findley. Findley obeyed and, on his way down, saw two more parachutes. He landed hard, was knocked unconscious and woke up to see three German farmers—two with pitchforks, one with a shotgun—standing over him.[100]

Second Lieutenant Robert Potter Dwight's turn came a month later. He was the copilot of the B-17 "Blythe Spirit," mortally hit on its bomb run. Shortly before, Dwight had gotten up to use the relief tube in the waist, then returned to his seat, got busy and forgot to fasten his restraining belts. Then three flak bursts came in rapid succession. One blew out the Plexiglas nose and took the bombardier with it. The second hit, which Dwight saw out his window, came between the Number Three and Four engines on the right wing. The wing began to buckle. The third flak burst hit near the bomb bay. Miraculously, the plane did not blow up, but the last hit threw

Sergeant Al Findley, prisoner of war photo. *Courtesy of Albert Lee Findley Jr.*

Dwight, with his restraints unbuckled, out of his seat. He hit his head on the airframe overhead. He then tumbled between the pilot and copilot's seat and fell again into the nose compartment, where he briefly registered that the navigator was still sitting at his plotting table and the bombardier was gone.

Dwight was stunned—he later realized that he must have jumped out the nose. Then he passed out, at twenty-eight thousand feet. He came to at two thousand and pulled the ripcord on his parachute. Pieces of his airplane were falling all around him. When the chute opened, he saw one more parachute—it was the navigator, Wait Hoffman. He would later learn that they were "Blythe Spirit's" only survivors.

Somewhere on the way down, Dwight realized he couldn't raise his arm. His shoulder was broken from his being thrown around the B-17's cabin. He landed in a stand of pine trees, rolled up his parachute, shoved it into a culvert under a road and followed it into the culvert while a column of German soldiers passed over him. They missed him.

He remembered the instructions to fliers to head west, toward Holland, if they were ever shot down. So he did, traveling by night. He eluded capture for five days until hungry, exhausted, and in pain, he grew careless and began moving west in daylight. When a farmer grabbed him at the edge of a field, it looked to Dwight as if his life was just about over.

Then a *Werhmacht* (German army) major miraculously appeared, riding a motorcycle with his sergeant in the sidecar. The sergeant pointed his rifle at Dwight, barked orders at the farmer and, in so doing, probably saved the American's life.

The major was not unpleasant. "We have been looking for you!" he told Dwight.[101]

Both Findley and Dwight were captured as the war entered its final months. Findley would later learn that he'd lost four crewmates; five others, besides Findley, became prisoners of war—it was two weeks before his pilot, Byron Johnson, was captured. The twenty-year-old radioman was put on a train to an interrogation center in Oberursel, north of Frankfurt, where he spent eleven days in solitary confinement, living on a diet of coffee, brown bread and "some kind of soup." He was finally interrogated by a Luftwaffe major who asked him about the impact of the new ballistic missile, the V-2, that was the last of Hitler's "miracle weapons" to be unleashed on Britain. Findley responded with his name, rank and serial number. He was a little rattled, as most captured airmen were, when his interrogator, in a little show, started talking about Findley's bomb group, the 466th—"he probably knew more about my outfit than I did," the American remembered.

Bob Dwight's interrogation officer affected a British accent, claiming he'd studied at Oxford. Dwight was just as surprised as Findley had been when the officer brought an easel into the interrogation room with an organizational chart of his 447th Bomb Group that included the names of every command and staff officer in the appropriate boxes. Dwight asked the German how they did that, and his answer was straight out of a wartime movie: "We have ways." Dwight responded that the chart was "very interesting" but refused to answer any questions and was soon dismissed.

The Luftwaffe's intelligence, as it turned out, lay in taking advantage of the democracy they were fighting and its freedom of expression. Intelligence staffs, according to historian Donald L. Miller, pored over hundreds of American magazines and newspapers, brought in through Portugal, for any information, including the wartime "Boys in the Service" columns common to small-town newspapers, that might help them learn more about the U.S. Army Air Forces. They also gathered any documents they could, down to ration cards, from downed bombers and the bodies of airmen killed in action. Finally, radio intelligence monitored every word spoken between planes or between bomb group and base during combat missions.[102]

Once downed fliers had been interrogated, their usefulness was at an end, and they then became part of the Luftwaffe-administered prison camp system. Al Findley was part of a prisoner-of-war shipment bound for a camp, Stalag XIII-D, near Nuremberg, Bavaria, sited on a parade ground that was once the scene, in Hitler's heyday, for Nazi Party rallies.[103] Findley remembered a camp that was overcrowded—Allied airmen in other camps had been brought to this one as the Red Army began to overrun eastern Germany—and rife with dysentery, bedbugs and fleas. "I think I spent

CENTRAL COAST AVIATORS IN WORLD WAR II

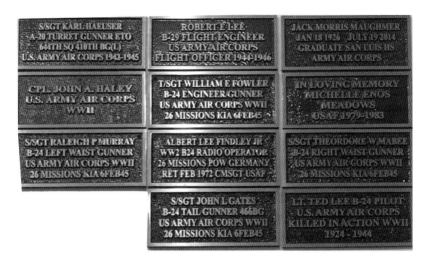

Al Findley's plaque in the Central Coast Veterans' Museum, San Luis Obispo, is flanked by the plaques memorializing the friends and crewmen he lost on February 6, 1945. *Author photo.*

half my time in the chow line," he remembered ruefully, where standard fare was soup with bugs in the beans, which he and his comrades decided were their meat supply. (In reality, the diet for German civilians wasn't much better.) The poor conditions were relieved by a reunion with his B-24 crew, with the pilot the last man to come into the prison camp. Pilot Byron Johnson cried when Findley and the other survivors told him about the four lost crewmen, including the lost flight engineer, the only husband and father among the crew, who had gone back to get the gunners out and wound up dying with them.

Bob Dwight's prison camp stay was brief, at Oflag 79, in Braunschweig, in Lower Saxony, where he was a distinct minority: Oflag 79 housed 2,700 British officers. Some of them had been in captivity for five years by the time Dwight arrived. Dwight was among about 90 American officers. Their camp was liberated in April by elements of Courtney Hodges's First Army as they drove east toward Berlin. The Americans left gifts in their wake: several cases of champagne and schnapps for the liberated prisoners of war; Dwight, who'd been living for six weeks on thin soup and little more—he'd lost twenty pounds by the time liberation came–was wise enough to abstain. "You never saw so many drunk or sick prisoners of war," he remembered.[104]

Findley's confinement ended on April 4, 1945, when the prisoners of Stalag XIII-D were ordered out and into the countryside as George Patton's Third Army closed in. While on the march, Findley and his

fellow prisoners had to endure friendly fire: they were strafed by American fighters who mistook them for German troops. (Findley's boxcar, on its way to Nuremberg, had likewise been strafed by Allied fighters.) At their stopping point the next day, the prisoners gathered enough toilet paper to spell out "POW" in the field where they were to sleep. Fighters passed over them, but this time the planes waggled their wings and departed. The bedraggled column finally stopped at Moosburg, ninety miles south of Nuremberg, where they were united with prisoners of war herded from Stalag VII. A week later, Findley and the mass of prisoners realized one morning that the Germans were gone. Third Army arrived at Moosburg at about noon, and Al Findley was free. Both Findley and Dwight would be flown to a recuperation center near Le Havre, Camp Lucky Strike, where their injuries would be tended to (Dwight's shoulder would eventually require surgery) and where, as Findley noted, "they fattened us up again." They were then put on ships and sent home.

Now, their war was finally over.

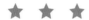

For copilot Robert Abbey Dickson of Morro Bay, the prison camp experience would be a long one: he was shot down over the Ruhr in December 1943, and his liberation, by the Red Army, rather than the Americans, would come in May 1945.

Dickson's ordeal as a prisoner of war resulted from a mission to bomb a chemical plant in the Ruhr Valley. It was a combination of both fighters and antiaircraft fire that doomed his B-17, "Wheel and Deal," which had survived an earlier mauling in March 1943 during a raid on the naval base at Wilhelmshaven, when its Number Four propeller was shot away. On this mission, Dickson's fifth, trouble began at the Initial Point, the beginning of the bomb run on the target. Two fighters came down from straight above—twelve o'clock high—to make passes at his bomber. The first fighter's gunfire found the Number Three engine, which sputtered and quit. The second fighter hit the leading edge of the left wing, and the B-17 suddenly lost all electrical power, its upper turret and ball turret frozen in place. (The bombardier would have to climb onto the catwalk that spanned the opened bomb bay doors, with miles to fall, to release the bombs manually.) "Wheel and Deal" had to drop out of formation,

making it even more vulnerable. As they struggled homeward, the German fighters returned to finish the bomber off, but a flight of American P-47 fighters scattered them.

The ordeal wasn't over. "Wheel and Deal" was losing altitude, and when it reached thirteen thousand feet, the flak guns were beginning to find the range. "We were getting pummeled," Dickson remembered. Shell fragments peppered the wings, and an unexploded shell came through the fuselage directly behind the pilot's seat. When another flak burst set an outboard engine afire, the pilot gave the bailout order. Dickson went out through the B-17's nose hatch and pulled his parachute's ripcord. Nothing happened. He struggled with the ripcord as he tumbled through the clouds, and finally, with the airman using both hands and all his strength, the ripcord gave and the parachute opened.

He came to earth in a little town near Dusseldorf, in the midst of what looked like a victory garden. That's where he was confronted by a civilian, probably, Dickson thought, a Great War veteran because he was armed with a vintage Mauser rifle. The German pointed the rifle at Dickson and ordered the American to put his hands in the air. That moment, to Dickson's relief, was a brief one; two Luftwaffe soldiers in a motorcycle and sidecar quickly arrived to take custody of the airman, whose descent they'd been following. They bundled their prisoner into the sidecar and, with the soldiers riding in tandem on the motorcycle, took him back to their headquarters, which happened to be an antiaircraft gun emplacement. Dickson was stunned:

> *They were the antiaircraft gunners who'd been firing at us just a few minutes before. They were rather nice to me. It was around noontime and they had some potato soup there, and they gave me a bowl of soup and then in broken English told me, "for you, the war is over." One sergeant told me he was going to take my* [silk] *parachute and send it home for his wife to make lingerie.*

The care the two men extended to Dickson continued when they took him in their motorcycle to a nearby Luftwaffe base. They had to go through Dusseldorf, where the Germans' hatred for the *terrorflieger*, "terror fliers," was palpable. One of Dickson's captors pointed a pistol at Dickson's head as their motorcycle passed crowded streetcars filled with civilians, who stared poisonously at the American. As soon as the motorcycle had passed the city center, the Luftwaffe soldier put his pistol away. It had been his way of protecting Dickson.

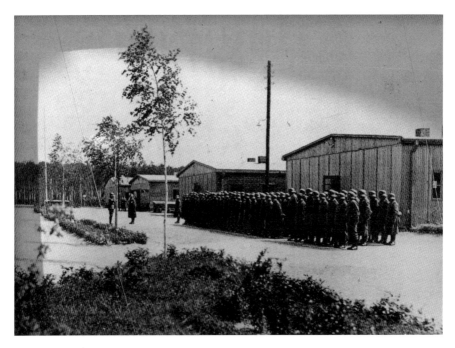

Roll call for the guard detail at Stalag IVB. *Wikimedia.*

Dickson was put into a solitary cell at the air base—where he found out the next day that nine of his ten crew were alive and prisoners, in their own cells, along with him. Their tail gunner, Sergeant William Roller, didn't make it. The survivors were then confined to the last car of a passenger train for a long, slow journey to an interrogation center near Frankfurt. The train made it to Cologne in time for an RAF raid. That's when the tension Dickson had experienced in Dusseldorf resurfaced; as the prisoners and civilians were herded into an air-raid shelter, British prisoners of war who spoke some German told Dickson and his aircrew that the civilians were discussing whether to kill the terrorflieger. Fortunately, the guards protected them and got them back onto the train. When their journey resumed, the guards opened the briefcases they'd been carrying with them. Dickson assumed those were for important papers, documentation on their captives. But when one guard popped open the latches on his briefcase, he took out a pocketknife, carved a thick slice of sausage, put it on some black bread and handed it wordlessly to Dickson.

Their destination was the same interrogation center that would have Lieutenant Dwight as a guest more than a year later. Dickson's anxiety

increased when he and his crew were separated again and put into dark individual cells, where bedding was a burlap bag stuffed with excelsior. His fear was compounded by the sounds outside of his cell: the hobnailed boot steps of the guards, the periodic bellowing of *Raus!* as one of his crewmates was taken out for interrogation. When Dickson's turn came, his experience was similar to Dwight's. The Luftwaffe major spoke with a British accent and chided him as "very foolish" when he stuck to name, rank and serial number. Dickson, too, was stunned when the major opened a desk drawer and removed a file, reading from it aloud: "Dickson, Dickson…I see your father was a major from World War I. You're from New Jersey. Oh! I've been to New Jersey! I see you have a brother and sister." Dickson was rattled, but he didn't have any information for the major, who dismissed him.

Two days later, Dickson and his aircrew were issued shoes, an overcoat and a toilet kit, but that moment of consideration was short-lived. They were taken to a railroad siding where the enlisted men and officers were separated. It was a painful moment for the young officer: "We never had a chance to say goodbye, or good luck, or anything. I never saw those guys again." The officers were put into converted cattle cars, fifty to sixty men to a car, with a crude bench and relief buckets, and sent on a two-and-a-half-day trip to Stalag Luft I on the Baltic Sea. There, Robert Dickson would spend the most tedious and dispiriting sixteen months of his life.

He had the comfort of sharing his assigned room, Room 9 in the south compound, with the pilot, navigator and bombardier of his aircrew—they would take turns at chores like cooking and dishwashing in barracks he remembered as drafty and cold. So were the guards, mostly older men or wounded veterans—there was very little interaction between the "kriegs," or prisoners of war, and their captors. The food was typical and monotonous; barley gruel and potato soup were staples. Once a week, a Red Cross food parcel arrived for each prisoner, containing a can of powdered milk or Spam, a chocolate bar and two packs of cigarettes. Since Dickson didn't smoke, he used his cigarettes as currency: two cigarettes, for example, would buy an onion, which the prisoners considered a delicacy.

Boredom may have been the most oppressive aspect of life at Stalag Luft I. There was a library, with a limited selection of dog-eared paperbacks, baseball and softball teams and enough band instruments for an orchestra. One of the captives had been a Broadway producer, and he organized a musical. Most of the time, the prisoners amused themselves by planning impossible escapes—impossible in large part because the local soil was so sandy that escape tunnels quickly collapsed. Regardless, the guards used

Art was one of the pursuits that prevented despair among POWs. An American flier created this fanciful B-17 "Flying Fortress" while captive in Stalag Luft I. *Museum of the U.S. Air Force.*

dogs and probes to search for tunnels, a routine that must have come even more frequently after the famed, but doomed, breakout by British prisoners of war at Stalag Luft III in the spring of 1944. The "Great Escape" resulted in the capture of seventy-three prisoners of war, with only three ultimately making it to freedom, and the execution of fifty of them at Hitler's orders.

A little more than a year later, in late April 1945, Dickson and his roommates could hear distant artillery fire. The Russians were advancing. On the night of April 30, the guards suddenly left—when Dickson woke up on May 1, the guard towers were empty. The American officer in charge ordered his airmen to stay put. There was still a war raging just outside the camp gates. That point was made with the first Russian Dickson saw: drunk, on horseback, waving his submachine gun to warn the prisoners to stay inside the barbed wire. The main body of Red Army troops arrived on May 2; it would be several weeks until the Americans were shuttled out from a nearby airfield in relays of B-17s. As they flew over Germany at low altitude, Robert Dickson was shocked by the damage the air campaign had wrought on German cities.[105]

★ ★ ★

The seas were so rough in the Strait of Malacca that the Japanese gunboat that finally picked up John Sanderson Gibson was crewed by seasick sailors. Gibson and his B-29 crewmates were taken to a former British prison in Singapore, and there the interrogations began. They were far harsher than those of the airmen in Europe had endured, and the Americans were interrogated, in rounds, by the military police, the *kempeitai*, then by the army and finally the navy. They were kept in solitary confinement, in cells where they slept on wooden floors, on a diet that was below subsistence—in six months, Gibson's weight dropped from 175 to 119 pounds. When they demanded to be treated according to the Geneva Conventions for prisoners of war—Gibson's pilot wanted his men to be held along with nearby British prisoners of war, but he was informed that Geneva did not apply: they were not prisoners of war, they were the personal prisoners of the Emperor. The implication was that the Japanese would do whatever they wanted to do with the American fliers.

To survive, Gibson relied on both guile and a bit of incredible luck. One of his early interrogators was a USC graduate, so Gibson, a Southern Californian, learned to deflect the usual interrogation by exchanging stories about Los Angeles and its attractions. But on another occasion, with a different interrogating officer, he was beaten by the attending enlisted man. The beating stopped momentarily so the officer could lean into Gibson and tell him earnestly, "You don't understand. We've got Gibson downstairs, and he's telling us everything. We don't know what you're holding out on." When a furious Gibson informed the officer that *he* was Gibson, he was immediately taken back to his cell. The interrogator had made a mistake, and to compound his error, he'd made it in front of his own enlisted man. It was a situation so humiliating for the interrogating officer that the prisoner was never questioned again.

The last thing Gibson relied on was his faith. He had been raised in a devout household, and when in the first weeks of his captivity he felt himself beginning to succumb to loneliness and despair, a powerful insight came to him: he would be a free man in six months. This moment of clarity kept him alive, and it turned out to be the truth. He bailed out of his B-29 on March 2, 1945. An American C-54 transport plane flew him out of Singapore on September 2—six months to the day. He was a sick man, enfeebled by starvation and dysentery, but he was alive. He was flown to Calcutta to recover, and eventually, he would, thanks to the intercession of his pilot, make it home. In his heart of hearts, Gibson had known all along that he would make it home.

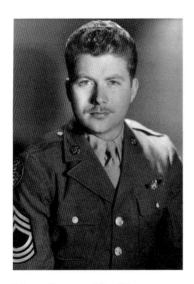

Master Sergeant John Gibson.
Courtesy of Bruce Gibson and family.

Gibson's love for his mother, his wish to spare her worry, had led him into a bad spot in their relationship. He had not told her, when he was first headed overseas, that he was to serve in a combat unit. He did not want her worrying. She found out the truth, as the Luftwaffe interrogators did in the Frankfurt processing center, from the hometown newspaper, when a little story credited Gibson's B-29 with five kills of Japanese fighters. A few weeks later, the clipping made it to Gibson with a handwritten note from his mother, tinged with the faintest trace of censure: "I'm glad to see at least that you're doing well."

Gibson's mother forgave him. She was a knitter and made socks for her three boys; before his capture, she asked him what he would prefer—plain, striped, argyle? He replied that he did not care as long as she was the one who knitted them. When John Gibson came home to California six months after his release from the Japanese prison in Singapore, he opened the dresser drawer in his bedroom. He found inside six brand-new pairs of socks that his mother had knitted for him.[106]

8

STRAFING RUNS

Aviation accidents were neither limited to distant airfields nor to aviation cadets. Santa Maria's army air field, on the site of the modern airport—Hancock's flying school, near Highway 101, would be replaced by Hancock College in the 1950s—became an advanced training base for pilots about to ship out as replacements, and they would refine their skills in the cockpits of P-38 Lightnings. Twin-engined fighter aircraft like the P-38 were not unique to the war—the Luftwaffe's twin-engined long-range fighter, the Messerschmitt Bf 110, had made its appearance early in the war, in the invasion of Poland. But both aircraft soon demonstrated critical weaknesses: the German fighters proved sluggish during the Battle of Britain and were easy prey for British Spitfires.[107] The Lightnings were fast—they could reach 440 miles per hour—and heavily armed, but they performed poorly at altitude in the cold of northern Europe and required constant and vigilant maintenance.[108] Meanwhile, fatal P-38 crashes marked the training tours of the Santa Maria pilots: one fighter went down in Oceano in 1944 in an explosion that could be felt three miles away;[109] another crashed into a Santa Maria café in January 1945, killing the pilot, the woman who was the café's co-owner and the cook.[110]

But the P-38 remained a formidable fighter plane, respected by many of the pilots who flew it, and its nose armament—four .50-caliber machine guns and a 20-millimeter cannon—made it lethal in air combat. The weaknesses and the strengths of the fighter were personally demonstrated to one of its pilots, the late Colonel Chester Eckermann, an Orcutt resident who died in

A P-38 Lightning's nose guns made it a formidable enemy. *U.S. Air Force.*

2012. As a young combat pilot, Lieutenant Eckermann—who would also see combat duty in the Korean War and would have a long and distinguished air force career—flew with the Eighty-Second Fighter Group, based in Foggia, Italy, and escorted Fifteenth Air Force heavy bombers on missions to Germany and southern France and over the Balkans. Eckermann had tremendous respect for the German Messerschmitt Bf 109, a "top-notch fighter," but on one mission, when he and his squadron mates encountered 109s that had intercepted the bombers they were protecting, the P-38 pilots discovered that their guns would not fire—they later found out that the guns' lubricant had frozen. But Eckermann bluffed his way out of the situation. The enemy pilots were so intimidated by the P-38's powerful array of guns that all Eckermann needed to do was to turn and point his plane's nose at the German fighters, which responded by breaking off and speeding away.[111] The incident demonstrated not only the fearsome reputation of this American fighter but also the devotion fighter pilots like Eckermann had for the bombers under their care. The bomber crews commonly, and deservedly, referred to their fighter escorts as "Little Friends."

Yet the P-38 was perhaps even more useful in strafing ground targets. By 1944–45, when American forces were beginning to make the weight of their numbers felt in Europe, ground support became the primary mission of fighters like the P-38. This happened, in part, because of General Tooey Spaatz's strategy in his "oil campaign"—as he'd predicted, German fighters came up in great numbers to challenge the American bomber fleets, and the escorting American fighters began to winnow away the Luftwaffe's cadre of veteran pilots. As the Luftwaffe became more and more enfeebled, sending up painfully young pilots with little experience—the Me-109 fliers that Eckermann had faced were doubtless very green—so the mission of American fighter pilots began to evolve. There would be no Red Barons

or Eddie Rickenbackers in the last year of the war. Their focus would turn more and more to destroying enemy troops, transport and combat aircraft on the ground.

The problem was that strafing runs on enemy ground targets were infinitely more dangerous (and less glamorous) than World War I–style dogfighting. Jay A. Stout, the biographer of San Luis Obispo pilot Elwyn Righetti, explained:

> *Indeed, there was no more dangerous mission* [than strafing ground targets] *for a fighter pilot. This was a fact borne out by the records as many more fighters over Europe were lost to ground fire than to enemy fighters. This was primarily because an aircraft flying a straight, predictable flight path* [the same vulnerability of B-17s or B-24s on their bomb runs] *low to the ground was vulnerable to the batteries of guns that typically protected important gunners. The enemy gunners needed only to shoot far enough ahead of the attacking aircraft to stand a reasonable chance of hitting it. Or—together with other gun crews—they could simply create a curtain of fire through which an aircraft had to fly.*[112]

Fighter pilots, then, traditionally the hunters, became instead the prey during strafing runs. They were like pheasants streaking across a field thick with shotguns.

It took time for American fighter commanders to realize this danger, and one victim of a strafing run that was planned foolishly was a P-38 pilot from Cholame, Second Lieutenant Jack Langston. In peacetime, Langston, a graduate of Atascadero High School, had been a talented saxophonist, playing in his Bakersfield College jazz band. Two weeks after D-day, he and his comrades in the 367th Fighter Group were ordered in over Cherbourg, France, a key port city at the edge of the Cotentin Peninsula. The Allies *had* to have a deep water port—the artificial harbor, or "Mulberry," on Omaha Beach, had broken up in a freak channel storm, so Cherbourg became a key objective. Here, the Americans could offload the reinforcements and supplies that would reinforce the hoped-for breakout from Normandy and then the drive toward the German frontier. But Cherbourg was heavily defended, a defense that included dense antiaircraft batteries, and the German infantry was giving ground grudgingly. The air attack was intended to deliver a shock that would break down their resistance.

That wasn't the way it worked out. Joe Griffin, a comrade of Langston's in the 367th, remembered their mission on June 22, 1944, with some

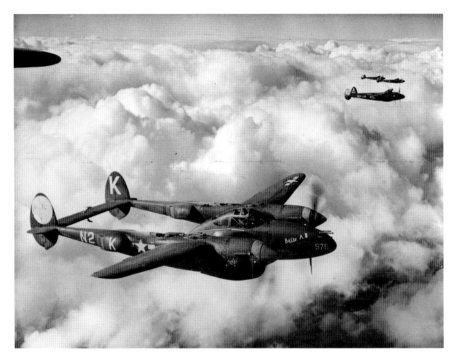

P-38s over England. *U.S. Air Force.*

bitterness. The first mistake in their orders had their flight path running *along* the length of the German antiaircraft corridor rather than *across* it. They were being asked to survive what must have seemed like interminable groundfire. The second problem came with ordering a high-speed attack at low altitude: Griffin found it almost impossible to locate and aim at a target—it was gone in an instant. While the fighters and fighter-bombers in the first wave might be protected by the suddenness and speed of their passes, those in subsequent waves became targets that were both close and on predictable flight paths. This is part of what Joe Griffin remembered and what Jack Langston endured:

> *Before I even had a chance to fire my guns or drop a bomb, there were two P-38s in front of me that crashed. The ground fire was the worst that I had ever experienced. I could feel bullets constantly hitting my plane. Instead of looking for targets, I was desperately trying to avoid being shot down by continually turning, skidding and jinxing all over the place. My efforts to avoid getting hit were highly unsuccessful and one of the bullets punctured*

the coolant radiator on my right engine. I started trailing a stream of liquid coolant that looked like smoke. When there is a cripple, it seems as though all the firepower in the area is concentrated on that one airplane. Within seconds they shot out my right engine and I had to feather it....

I condemn our leaders who planned that mission for not recognizing that their plan eliminated the element of surprise, exposing our planes to very concentrated and deadly ground fire, with little if any positive results. We should have been sent over the target area from different directions to have [at] least caused the enemy confusion.[113]

Griffin jettisoned his bombs and made it home on one engine, a skillful piece of flying. But at 1:15 in the afternoon, a flak burst hit Second Lieutenant Langston's fighter. The plane caught fire, and witnesses on the ground saw the pilot bail out.[114] No one saw Jack Langston afterward. He is recorded among the missing in action at the beautiful American cemetery at Colleville-sur-Mer, on the cliffs above Omaha Beach.

Five months after the ill-fated mission over Cherbourg, coordination between American ground forces and the planes providing their air cover had improved, thanks in large part to Ninth Air Force commander Pete Quesada, a young general who sent pilots into the front lines with ground troops. There, they served as spotters and relayed, via VHF radio, target information to the fighters and fighter-bombers overhead.[115]

But no innovation could prevent bad weather, and on December 16, 1944, when the Wehrmacht launched the winter offensive, Operation Nordwind, that would evolve into the Battle of the Bulge, it was helped immensely by a weather front that settled over northern Europe for a week. Thick cloud cover and fog prevented American and British planes from providing air support. The German armored and infantry attack in the Ardennes knocked the Americans in Belgium and Luxembourg back on their heels. Within a few days, it looked as if Hitler's last great offensive might achieve its goal of driving to the Channel and splitting the American and British armies in two.

The Americans got an early Christmas gift on December 23. The weather cleared. That day alone, two thousand air sorties were flown, both combat

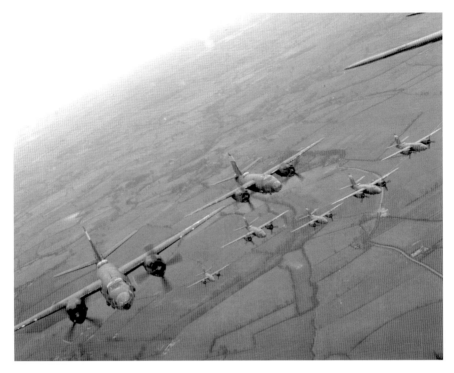

A flight of B-26 Marauder medium bombers. *Museum of the U.S. Air Force.*

A German military train hit by Ninth Air Force fighters. *Museum of the U.S. Air Force.*

missions and supply missions to the 101st Airborne, besieged in Bastogne, Belgium. A few miles away, another Belgian town, Houffalize, lay at a crucial crossroads in a part of the front where the Americans and Germans were deadlocked. Antiaircraft fire around Houffalize on December 26 would bring down the B-26 Marauder piloted by First Lieutenant James Pearson of Templeton, killing every man of his five-man crew. Even if AAF tactics had improved, the dangers of low-level missions, either for fighters or the medium bombers like Pearson's Marauder, were no safer. But the sacrifices fliers like Pearson exacted on the Wehrmacht were even greater: the U.S. Army Air Forces estimates, by the time the offensive was finally crushed in mid-January 1945, included the destruction of 11,378 transport vehicles, 1,161 tanks and 1,600 aircraft.[116] These were losses the Wehrmacht could not make good, and many of the kills the air forces recorded were made easier because hundreds of German vehicles simply ran out of fuel, a tribute in part to the heavy bombers' oil campaign. Hitler's vaunted blitzkrieg had exhausted itself in Belgium.

One factor in the German war effort that had not been exhausted by January 1945 was Hitler's imagination, which included his faith that an array of wonder weapons—like the V-1 "buzz-bomb," the V-2 rocket, the greatly feared Me-262 jet fighter—would reverse the tide of war. On January 28, an ungainly looking and unlikely sounding new weapon, a jet fighter made of wood, the He-162, first came off the assembly line. It had experienced a birth every bit as painful as the American B-29 bomber's had been: a prototype had crashed and killed its revered test pilot, Gotthard Peter; the airframe was too light for the recoil of the original weapons, two 30-millimeter cannon; and the pilot, if he had to bail out, had to contend with the intake of the aircraft's jet engine, which lay directly behind the cockpit (a problem allegedly solved by installing an ejection seat in later models).

The He-162, dubbed the *Volksjager*, "People's Fighter," was to be tested by factory pilots that included seventeen-year-old Harald Bauer, who today lives in Atascadero. Bauer and his comrades would give their assigned plane, just out of the factory, a twenty-minute test flight and then would ferry it to its Luftwaffe base. Bauer estimates that he did this ten or fifteen times. He would then hitch a ride back to the Heinkel factory. His last trip, on March

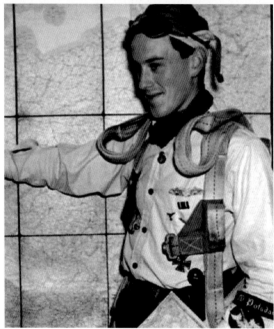

Above: A captured He-162—the same kind of jet flown by Harald Bauer—on display in postwar England. *National Archives.*

Right: Teenaged test pilot Harald Bauer. *Courtesy of Hometown Heroes Radio.*

24, 1945, was his most memorable. After landing his Volksjager at a base near Varel, Bauer was ordered to get the jet fighter off the runway in the advance of a raid by B-17s of the 490th Bomb Group.

He started the engine and got airborne, but then, Bauer recalled, he saw "red tracers coming down on both sides of the cockpit. Then one hit the engine, came through the canopy and buried itself in my leg." He'd been

bounced by a P-51 Mustang that had peeled away from its escort mission with the 490th. A stunned Bauer immediately rejected any thought of bailing out. He had no ejection seat, and the mouth of the BMW jet engine was looming just behind him. Instead, he stayed with the plane and gingerly brought the fighter, which glided no more gracefully than a freshly baked brick, down in a meadow. The next thing he recalled was the voice of a big American sergeant from the 2nd Armored Division calling to his comrades: "That sonofabitch is still alive!"[117]

The Americans took Bauer to a field hospital, where a surgeon later presented the young man with the bullet he'd extracted from his leg. When interrogators discovered that Bauer's mother was American-born, they did him one more favor. As First Army neared Kassel, where his mother lived, a U.S. Army ambulance delivered him to the front door. When Mrs. Bauer opened it, the orderlies greeted her with the kind of announcement every soldier's mother deserved: "Here's your son, Ma'am."

After the war, Bauer would begin a career as a newspaper reporter and win a Fulbright Scholarship to study journalism in America, at the University of Kentucky. It was flying that briefly interrupted a distinguished career with the Associated Press; Bauer became the pilot of intelligence-gathering aircraft during the Korean War on flights that skirted the border of the Soviet Union. Heinkel test pilot Harald Bauer ended his remarkable military career as Commander Hal Bauer, U.S. Navy.

It was a P-51 that had shot down Bauer's jet fighter. For First Lieutenant William Pope, who died in Paso Robles in 2009, the P-51 was a turning point in a military career that would span almost thirty years. A Wisconsin native, Pope's war began with the attack on Pearl Harbor. He was stationed on the north side of Oahu, and his contribution that maddening Sunday was, along with his AAF comrades, using bolt-action 1903 Springfield rifles to reply to the strafing of an Aichi 99 "Val," a Japanese dive bomber. They did little damage that day, but over two years later, Pope would be a P-38 pilot in the Fifty-Fifth Fighter Group, based in England. Pope was not a devotee of the twin-engined Lightning. In addition to its sluggishness at or above twenty-five thousand feet, it was bitterly cold—the pilot's pod was isolated from the engines, so the cabin

lacked the heat the engine provided in more conventional fighter aircraft.

The fighter's cold-weather performance meant that Pope's fighter group lost a lot of P-38s. There were few things worse, he remembered later, than returning to base and finding a wingman's mattress rolled up on his bedframe. That friend wasn't coming home. Most of his early missions were escorting the heavy bombers into "big fights," including missions over Berlin. "You see an airplane like a B-17 go down," he said many years later, "and you know there's ten kids on there…it's very tough." He would later fly strafing missions over Normandy prior to the invasion to soften up German defenses and flew cover during the invasion itself.

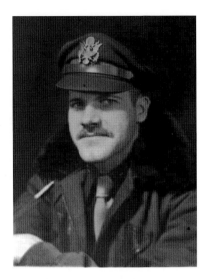

William K. Pope of Paso Robles as a pilot with the Fifty-Fifth Fighter Group. *Courtesy of Sheila Reiff.*

For Pope, "the whole war changed" in July 1944 when the Fifty-Fifth was introduced to the P-51 Mustang. He instantly fell in love with the fighter whose performance, he realized, gave him and his comrades a far better edge over the Luftwaffe fighters and gave them all a far better chance at survival. But he almost didn't survive his most memorable mission, to Stuttgart in September. His wingmate spotted aircraft moving on the ground below them, and Pope dove down to take a look. They were Heinkel 177 medium bombers. Pope made a strafing run and got one, then did something he characterized as "dumb": he made a second pass and then a third. On the third pass, he got his second kill that day. The temptation was far too strong for the young lieutenant—on his fourth pass, he realized that every gun on the ground was firing at his plane. He could hear the "plunks" of hits on his airframe and knew he'd made a mistake. Pope saved his life and his airplane by banking hard and finishing off his fourth and final pass by threading the needle, at high speed, between the German airfield's two hangars.[118]

Seven months later, another veteran Mustang pilot would make the same mistake that Pope had.

Lieutenant Colonel Elwyn Righetti of San Luis Obispo was the young man who'd left the family's dairy farm to pursue a career in the U.S. Army Air Forces. Righetti's rise in rank was rapid, if it didn't seem so to him at the time, and after years as a flight instructor, he would assume command of Pope's 55th Fighter Group. If his enthusiasm was contagious—his nickname was "Eager El"—it was balanced by a humility that was a harbinger of good leadership. Righetti assumed the command of a veteran P-51 unit, and he was a newcomer to combat, so he flew an early mission, on November 2, 1944, under the command of a combat leader inferior to him in rank, Captain Darrell Cramer. It would be Cramer who briefed the 338th Squadron of the 55th that day and it would be he who led them into combat. Righetti was his wingman—just another flier in the squadron. They were to escort bombers in a raid on a synthetic fuel factory.

On this mission, Eager El quickly validated his nickname, and it got him into trouble. When Cramer spotted an enemy fighter, an Me-109, he called it as an outfielder might call a fly ball and opened fire with his machine guns. He could see that he'd scored some hits. Suddenly, another P-51 appeared from Cramer's left. It, too, was firing on the German fighter and scoring hits, but the pilot had flown directly into Cramer's line of fire. The trespasser was Colonel Righetti. When the squadron returned to base, Cramer debriefed his pilots, including an ebullient Righetti. Later, when the two were alone, Cramer lit into his superior officer: Righetti had committed a breach of air discipline that would have grounded a junior officer for two weeks. He was Cramer's wingman, and it was his job to protect his flight leader and to know where he was at all times. Righetti had instead gone for a kill that had, in fact, endangered both American pilots.

A deflated Righetti knew he'd been in the wrong. He took the chewing-out stoically and never made that mistake again.[119]

It was on a mission on his thirtieth birthday—April 17, 1945, when Righetti demonstrated another element of good leadership: compassion. By the time of that mission, Eager El had earned the respect and the affection of his fliers, and the Fifty-Fifth's P-51s had accumulated,

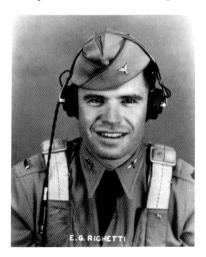

Elwyn Righetti as an aviation cadet. *Museum of the U.S. Air Force.*

under his command, the destruction of nearly one hundred enemy aircraft and over two hundred ground targets (e.g. vehicles, trains, artillery batteries).[120] The birthday mission was an escort mission, protecting B-17s on yet another raid on Dresden. After he'd finished briefing his pilots, Righetti took one of them, Paul Reeves, aside and talked to him quietly. Reeves had nearly been killed on an earlier mission, when an enemy shell exploded in his cockpit, tore a chunk out of one wing, destroyed his compass and covered his cockpit with a layer of oil. Reeves somehow made it back to base—his engine seized soon after he'd parked—and perhaps Righetti felt that this pilot had used up his supply of luck. The April 17 mission was to be Reeves's last. Righetti told him to take the lead, but as soon as the fighters reached enemy territory—had flown far enough to qualify for a completed mission—he was to let Righetti assume the lead. Reeves was then to turn around and fly home. Eager El explained that the Fifty-Fifth had already lost too many pilots on their last missions, and he had no intention of letting that happen to Paul Reeves. He ordered another pilot on his last mission, Frank Birtciel, to do the same.[121]

Instead, this birthday mission would be Elwyn Righetti's last.

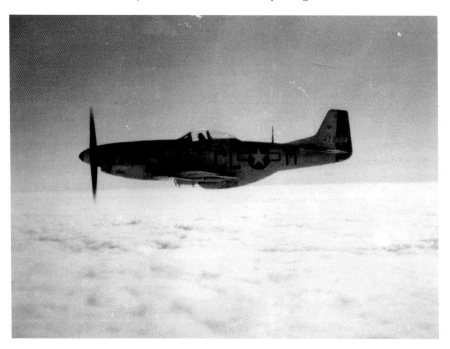

Lieutenant Colonel Righetti in the P-51 he named for his wife, "Katydid." *Museum of the U.S. Air Force.*

When his squadron was relieved by a second relay of Mustangs, Righetti led his pilots below the clouds to seek out targets of opportunity. He and his wingman that day, Carroll Henry, found them in a group of parked fighters at an air base near Riesa, Germany. By now, fighter pilots had learned that their accuracy—and Righetti was an expert shot—demanded slower passes during strafing runs, which, of course, made the fighter more vulnerable to antiaircraft fire. Righetti was on his third pass, one he perhaps should not have attempted, when Henry saw his commander's plane get hit. It was leaking coolant. The engine seized. Righetti managed to bring the Mustang down safely in a field, but he smashed his face in the gunsight on impact. "I broke my nose," he radioed, "but I'm okay, I got nine today, tell my family I am OK, and it has been swell working with you."

Righetti was never heard from again. He may have been killed by civilians, like those who came so close to killing downed bomber pilot Harold Schuchardt. Red Army forces were in the area, and Righetti might have been killed by their artillery or was captured by them only to disappear into the vastness of Stalin's prison camp network, the *gulag*. He remains among seventy-nine thousand Americans missing in action in World War II.[122]

Epilogue

NAGASAKI, HICKAM FIELD

If there is one man who can measure the cost of the war in the air, it is retired Cal Poly architecture professor John Sim Stuart, a dignified man with a courtly accent that reveals his Texas origins. Stuart was a talented teacher who delighted his materials of construction students with his insistence on precision in their language: "There is no such thing as a 'cement' sidewalk! Cement is nothing more than gray powder! It's a *concrete* sidewalk!"[123] Long before his teaching career began—and long before he'd started his career as an architect—he entered the AAF cadet program in San Antonio, persisted despite the usual indignities that young "gooney birds" were forced to endure, survived the hazards of learning to fly that claimed the lives of so many cadets and was chosen to fly a premier American fighter plane during World War II: the big P-47 Thunderbolt, another plane known for dogfighting and for the havoc it visited on ground targets.

It was Stuart's talent as a teacher that almost kept him out of the war altogether. The AAF kept him stateside as a flight instructor and gunnery instructor, and he wouldn't be shipped out with his 507th Fighter Group until April 1945; the P-47 pilots would finally reach their forward base on Ie Shima in July. He and his squadron began flying bombing and strafing missions over Japan, ranging as far north as Korea, where they struck an enemy air base. On August 6, the squadron went on a sweep over Shikoku, one of Japan's home islands, and they were ordered to keep their distance from three cities designated as targets for the day.

One of them was Hiroshima.

Epilogue

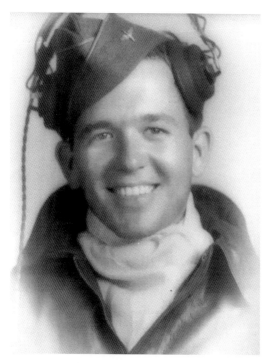

Left: John Sim Stuart as an aviation cadet. *Courtesy of John Sim Stuart.*

Below: The Nagasaki bomb. *U.S. Air Force.*

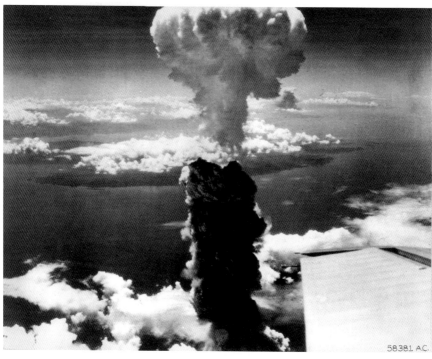

Epilogue

When the young pilots later learned what had happened, they began to think, as Stuart did, that maybe they would make it through this war after all. The resistance that American ground forces had faced on Iwo Jima and Okinawa suggested to the fliers of the 507th that the war would not be over soon. Their lives, on the other hand, might be.

Three days later, on another fighter sweep, the pilots were again ordered to keep their distance from three more cities, and one of them, of course, was Nagasaki. While doing what good fighter pilots were trained to do—keeping his head in near-constant motion, looking for potential targets or potential fighter attacks—Stuart saw the flash of the second bomb, a fiery red hemisphere that dissipated to be replaced by the mushroom cloud that would become such an evocative image during the new war, the Cold War, that was to come. Stuart and his comrades quickly turned their gun cameras on to record the cloud's climb into the skies. The film was confiscated as soon as they returned to Ie Shima.

Six days later—it was August 14 in the United States, across the International Date Line—the 507th was among the units that witnessed the landing of the Japanese surrender delegation on Ie Shima. The group flew in on a twin-engined "Betty" bomber, painted white and escorted by P-38s, and then boarded another plane for a flight to the Philippines to sign the preliminary surrender documents. World War II would officially end on the quarterdeck of the battleship *Missouri* on September 2, where General Douglas MacArthur presided over the formal surrender.

The deaths that Stuart had seen in the Nagasaki flash—an estimated forty thousand—were horrific, but the terrible bomb had exploded far away. The war would not spare John Stuart losses much closer.

Before Stuart had shipped out for combat, when he was a gunnery instructor at the Pierre, South Dakota, Army Air Field, he struck up what were among the closest friendships of his life, with fellow instructors Ray Ranger and Frank Mrenak. They soon found a watering hole, the Hopscotch Inn, across the Missouri River in Fort Pierre, that had the extra attraction of being in another time zone. They could enjoy an extra hour of beers before closing time. That's what Stuart and Ray Ranger were doing one night when a party of four came in and took a table. That immediately caught the aviators' attention, because half the party was made up of attractive young women. Marge Starkey was there with her parents and her friend Mary Bowen. Ranger and Stuart politely asked the Starkeys if they might dance with "your daughters." Ray's partner was Marge; John Stuart's was Mary.

Epilogue

Left: John Sim Stuart and the P-47 he named for his bride. *Courtesy of John Sim Stuart.*

Below: Three friends, fellow instructors, at the Pierre, South Dakota Army Air Forces Base. Only one of them would survive the war; (*left to right*) Frank Mrenak, John Sim Stuart, Ray Ranger. *Courtesy of John Sim Stuart.*

John and Mary met at the Hopscotch to dance every night for the next week. When John proposed, Mary accepted. At first, they decided to wait until Stuart's combat tour was finished. They then decided that didn't make any sense. They married in September 1944 and are, after seventy-three years, still married.

Mary Stuart—the name John would give to his P-47—then entered a life typical of military wives: she followed John to postings in Nebraska and then

Epilogue

to Texas before he left her to go overseas in April 1945. John's friendship with Frank and Ray endured—Ray had been the best man at the Stuarts' wedding—and they followed the 507th to those new postings as well. Mary was sitting at a table with the two during a party when Ray turned to her and spoke earnestly: "Mary, I don't think you have to worry about J.S. [John]. I think he'll come back from this war. I'm not sure that Frank and I will."[124]

Ray Ranger was right, as soldiers contemplating their own fates sometimes are. Ray's P-47 was escorting a flight of B-24 bombers to targets on Kyushu when the mission was recalled. On the way home, he reported engine trouble, and witnesses saw the plane fall into the sea.[125] His body was never recovered.

By then, Frank was already gone. Soon after the fighter group arrived in Hawaii, in April 1945, his Thunderbolt dove into the ground and exploded at the southeast edge of Hickam Army Airfield, which had been one of the primary targets of the Pearl Harbor strike force on the morning of December 7, 1941.[126] John Stuart's friend, First Lieutenant Frank Mrenak, one of forty thousand American airmen killed in World War II, died where their war had begun.

NOTES

Prologue

1. "303rd BG(H) Combat Mission No. 20, 6 March 1943," 303rd Bomb Group (H), http://www.303rdbg.com/missionreports/020.pdf.
2. Eddie Deerfield, editor, *Hell's Angels Newsletter*, "The Terrifying Last Mission of the Mart in Plocher Crew," May 1999; "303rd BG(H) Combat Mission No. 20."
3. The details about Clair Abbott Tyler's life are taken from *San Luis Obispo Telegrams* and *Telegram-Tribunes* beginning November 24, 1931, and ending August 27, 1943.

Chapter 1

4. Wilmar N. Tognazzini, compiler, "100 Years Ago: July 5, 1898–July 12, 1898," http://wntog.weebly.com/1898.html.
5. Carly Courtney, "Lincoln J. Beachey: The Tragic Rise and Fall of the Master Birdman," *Disciples of Flight*, October 31, 2016, https://disciplesofflight.com/aviation-pioneer-lincoln-j-beachey.
6. "Official Program for Celebration that Began This Afternoon," *San Luis Obispo Daily Telegram*, July 2, 1910, 3.
7. Frank Marrero, "Lincoln Beachey: The Forgotten Father of Aerobatics," *Flight Journal* magazine, April 1999, http://www.frankmarrero.com/Beachey/The_Forgotten_Father_of_Aerobatics.html.

8. David Middlecamp, "Aerial Pioneer Harriet Quimby," *San Luis Obispo Tribune*, July 14, 2010, http://sloblogs.thetribunenews.com/slovault/2010/07/aerial-pioneer-harriet-quimby.
9. "Harriet Quimby," National Aviation Hall of Fame, accessed June 17, 2017, http://www.nationalaviation.org/our-enshrinees/quimby-harriet.
10. Earl Miller, "Famous Flier Inspects Poly Aerial Building," *San Luis Obispo Daily Telegram*, June 25, 1936, 1.
11. Leroy McChesney III interview with author, Arroyo Grande, California, May 9, 2017.
12. "Airplane Lands at Arroyo Grande by Mistake," *San Luis Obispo Tribune*, March 22, 1922.
13. Barnes McCormick, Conrad Newberry, Eric Jumper, eds., *Aerospace Engineering during the First Century of Flight* (Reston, VA: American Institute of Aeronautics and Astronautics, 2004), 861–62.
14. "Matriarch of Music in SLO Dies at 98," *San Luis Obispo Tribune*, December 7, 2010, http://www.sanluisobispo.com/news/local/article39139020.html.
15. "Guardsman Praises Airport," *San Luis Obispo Daily Telegram*, February 17, 1939, 1.
16. "Learn to Fly!," *San Luis Obispo Telegram-Tribune*, September 6, 1940, 20.
17. Jay A. Stout, *Vanished Hero* (Havertown, PA: Casemate Publishers, 2016), 18.
18. Ibid., 53–54.

Chapter 2

19. Read D. Tuddenham, "Soldier Intelligence in World Wars I and II," http://www.iapsych.com/iqmr/fe/LinkedDocuments/tuddenham1948.pdf.
20. Elena Sullivan, "Cal Poly Women: Roles and Depictions during World War II," research paper, History 303-01, California Polytechnic University–San Luis Obispo, March 2016, http://digitalcommons.calpoly.edu/cgi/viewcontent.cgi?article=1022&context=cphistory.
21. Robert E. Kennedy, *Learn by Doing Memoirs of a University President*, monograph, California Polytechnic University–San Luis Obispo, 2001, 83.
22. Eldon N. Price, *Senior Birdman: The Guy Who Just Had to Fly* (iUniverse Inc. Publishing, 2006), 21–22.
23. Wendell Bell, *Memories of the Future* (New Brunswick, NJ: Transaction Publishers, 2012), 42–43.
24. "Boeing / Stearman PT-17 'Kaydet,'" Warbird Alley, accessed June 21, 2017, http://www.warbirdalley.com/pt17.htm.

25. The accounts of San Luis Obispo County airmen lost to training accidents come from various issues of the *San Luis Obispo Telegram-Tribune*, 1943–45.
26. Marilyn R. Pierce, "Earning Their Wings: Accidents and Fatalities in the United States Army Air Forces During Flight Training in World War Two," PhD dissertation, Kansas State University, Manhattan, Kansas, 2013.
27. "Capt. G. Allan Hancock," Allan Hancock College, accessed June 22, 2017, http://www.hancockcollege.edu/public_affairs/capt-hancock.php.
28. Justin Rughe, "Historic California Posts, Camps, Stations and Airfields: Hancock Field," accessed June 22, 2017, http://www.militarymuseum.org/HancockField.html.
29. Mike Geddry Sr., Santa Maria Museum of Flight CEO, interview with author, May 4, 2017
30. Eugene Fletcher, *Mister: The Training of an Aviation Cadet in World War II* (Seattle: University of Washington Press, 1992), 61–62.
31. John C. McManus, *Deadly Sky: The American Combat Airman in World War II* (New York: New American Library, 2000), 23.
32. Stout, *Vanished Hero*, 23.
33. "Lt. Hagerman, Paso Robles, Killed in Air Crash," *San Luis Obispo Telegram-Tribune*, February 14, 1944, 1.
34. "Dorothy May Moulton Rooney," oral history interview by Joanne Cargill, January 27, 2010, Dorothy May Moulton Rooney Collection (AFC/2001/001/71857), Veterans History Project, American Folklife Center, Library of Congress.
35. "Betty Pauline Stine," Together We Served, accessed June 23, 2017, https://airforce.togetherweserved.com/usaf/servlet/tws.webapp.WebApp?cmd=ShadowBoxProfile&type=PersonAssociationExt&ID=22008.
36. "Above and Beyond: Gertrude 'Tommy' Tompkins-Silver," Above and Beyond, accessed June 23, 2017, http://www.wingsacrossamerica.org/above---beyond.html.
37. Susan Stambeg, "Female WWII Pilots: The Original Fly Girls," NPR transcript for *Morning Edition*, March 9, 2010, http://www.npr.org/2010/03/09/123773525/female-wwii-pilots-the-original-fly-girls.
38. Katherine Sharp Landdeck, "A Woman Pilot Receives the Military Funeral the Army Denied Her," *The Atlantic*, September 8, 2016, https://www.theatlantic.com/politics/archive/2016/09/wasp-elaine-harmon-arlington-national-cemetery/499112.
39. "WASP Final Flight: Sylvia Barter, 43-W-7," Final Flight, accessed June 23, 2017, http://waspfinalflight.blogspot.com/2009_02_01_archive.html.

Chapter 3

40. "Albert Lee Findley Jr.," oral history interview by Joy Becker, September 26, 2013, Albert Lee Findley, Jr. Collection (AFC/2001/001/93273), Veterans History Project, American Folklife Center, Library of Congress.
41. "Consolidated B-24J Liberator," last modified July 4, 2007, http://www.joebaugher.com/usaf_bombers/b24_18.html.
42. "Robert Abbey Dickson," oral history interview by Joanne Cargill, September 19, 2007, Robert Abbey Dickson Collection (AFC/2001/001/56287), Veterans History Project, American Folklife Center, Library of Congress.
43. Jay A. Stout, *Hell's Angels: The True Story of the 303rd Bomb Group in World War II* (New York: Berkley Caliber Books, 2015), 96–98.
44. Don Moore, "He Flew with Jimmy Stewart in WWII," War Tales, accessed June 24, 2017, https://donmooreswartales.com/2010/05/05/jim-myers.
45. Sam McGowan, "The Boeing B-17 Flying Fortress vs. the Consolidated B-24 Liberator," Warfare History, June 30, 2017, http://warfarehistorynetwork.com/daily/wwii/the-boeing-b-17-flying-fortress-vs-the-consolidated-b-24-liberator.
46. "Harold Edgar Schuchardt," oral history interview by Joanne Cargill, May 10, 2007, Harold Edgar Schuchardt Collection (AFC/2001/001/51597), Veterans History Project, American Folklife Center, Library of Congress.
47. "Duties and Responsibilities of the B-17 Crewmen," 303rd Bomb Group (H), accessed June 23, 2017, http://www.303rdbg.com/crew-duties.html.
48. "Aerial Bombs," 303rd Bomb Group (H), accessed June 27, 2017, http://www.303rdbg.com/bombs.html.
49. John T. Correll, "Daylight Precision Bombing," *Air Force Magazine*, October 2008, http://www.airforcemag.com/MagazineArchive/Pages/2008/October%202008/1008daylight.aspx.
50. Sandra MacGregor, "Richard Cowles, World War II Tailgunner," *SLO Journal Plus* (August 2015): 28–29.
51. McManus, *Deadly Sky*, 37–42.
52. "Albert Spierling," oral history interview by Joanne Cargill, November 21, 2003, Albert A. Spierling Collection (AFC/2001/001/10402), Veterans History Project, American Folklife Center, Library of Congress.
53. Major James J. Carroll, "Physiological Problems of Bomber Crews in the Eighth Air Force during World War II," paper prepared for the Air

Command and Staff College, March 1997, http://www.dtic.mil/cgi-bin/GetTRDoc?AD=ADA398044.
54. "Richard Vane Jones," oral history interview by Joy Becker, May 7, 2009, Richard V. Jones Collection (AFC/2001/001/71933), Veterans History Project, American Folklife Center, Library of Congress.
55. "Henry Joe Hall," oral history interview by Joy Becker, May 21, 2009, Henry J. Hall Collection (AFC/2001/001/71890), Veterans History Project, American Folklife Center, Library of Congress.

Chapter 4

56. Elizabeth Grice, "War Memories: John Keegan's Life and Times," *Telegraph*, September 17, 2009. http://www.telegraph.co.uk/culture/books/6203052/War-memories-John-Keegans-life-and-times.html.
57. *Foot Soldiers*, "The Allies," film, the History Channel, 1998.
58. Donald L. Miller, *Masters of the Air* (New York: Simon and Schuster Paperbacks, 2006), 137–38.
59. "Albert Spierling," oral history interview.
60. Jerome O'Connor, "U Boat Sanctuary—Inside the Indestructible U Boat Bases in Brittany," January 1, 2008, http://historyarticles.com/gray-wolves-den.
61. "The Bombing of Germany 1940–1945: Allied Air-Strikes and Civil Mood in Germany," University of Exeter, accessed July 2, 2017, http://humanities.exeter.ac.uk/history/research/centres/warstateandsociety/projects/bombing/germany.
62. "Individual Deceased Personnel File: 1st Lt. Clarence H. Ballagh," American Air Museum in Britain, accessed June 2, 2017, https://www.americanairmuseum.com/person/32316.
63. "Sidewalk dedication, 1944, Arroyo Grande, California," Ancestry, accessed June 2, 2017, https://www.ancestry.com/media/viewer/viewer/c22332c1-e9fc-40d8-8b55-cbc5d6b3488b/7516801/-1076227646.
64. Cess Steijger, "Crazy Horse," accessed July 2, 2017, http://b17crazyhorse.nl/?page_id=34.
65. "File 164. 1944-02-21/21 B-17 42-30280 Holcombe IJsselmeer Zeewolde," accessed July 2, 2017, http://www.zzairwar.nl/dossiers/164.html.
66. J. David Rogers, PhD, University of Missouri-Rolla, "Doolittle, Black Monday, and Innovation," accessed July 4, 2017, https://web.

mst.edu/~rogersda/american&military_history/Doolittle-Black%20 Monday-Need%20for%20Innovation-1944.pdf.
67. Jody Kelly, Ninety-First Bomb Group historian, telephone communication, July 9, 2017.
68. "Marshall Stelzriede's Wartime Story: The Experiences of a B-17 Navigator During World War II," accessed June 17, 2017, http://www.stelzriede.com/ms/html/marshwcp.htm.

Chapter 5

69. Roy Lee Grover, *Incidents in the Life of a B-25 Pilot* (Bloomington, IN: AuthorHouse, 2006), 40–41.
70. "John Sim Stuart," oral history interview by Joy Becker, November 17, 2009, John Sim Stuart Collection (AFC/2001/001/71863), Veterans History Project, American Folklife Center, Library of Congress.
71. McManus, *Deadly Sky*, 110.
72. Captain James J. Sapero, USN, "Tropical Diseases in Veterans of World War II," *New England Journal of Medicine* 235, no. 24 (December 1946): 843.
73. Grover, *Incidents*, 40–41.
74. Ibid., 37–38.
75. Allen D. Boyer, "Legendary WWII Pilot Pappy Gunn Gets His Due in New Biography," *The Oregonian*, November 27, 2016, http://www.oregonlive.com/books/index.ssf/2016/11/indestructible_pappy_gunn_john.html.
76. "Roy Lee Grover, 2014 Veterans' Day Honoree," University of Utah, accessed July 8, 2017, http://veteransday.utah.edu/?p=2543.
77. Joseph Rogers, "Arthur Rogers: The Jolly Rogers," accessed July 7, 2017, https://prezi.com/5syuymfh9obl/arthur-henry-rogers-the-jolly-rogers.
78. "B-24J-150-CO Liberator Serial Number 44-40188," Pacific Wrecks, accessed June 20, 2017, https://www.pacificwrecks.com/aircraft/b-24/44-40188.html.
79. "County Men in the Fight: Purple Heart Award," *San Luis Obispo Telegram-Tribune*, February 27, 1945, 1.
80. "Historical Snapshot: B-29 Superfortress," Boeing Corporation, accessed July 8, 2017, http://www.boeing.com/history/products/b-29-superfortress.page.

81. "John Sanderson Gibson," oral history interview by Margie Shafer and Maxine Fischer, July 14, 2003. John Sanderson Gibson Collection (AFC/2001/001/07842), Veterans History Project, American Folklife Center, Library of Congress.
82. "Aviation History Online: Boeing B-29 Superfortress," accessed July 9, 2017, http://www.aviation-history.com/boeing/b29.html.
83. Jack Nilsson's biographical information comes from several stories from the *San Luis Obispo Telegram-Tribune*, 1931–40.
84. Joe Baugher, "B-29 Attacks on Japan from the Marianas," March 15, 2002, http://www.joebaugher.com/usaf_bombers/b29_10.html.
85. Herman S. Wolk, "The Twentieth Against Japan," *Air Force Magazine* (April 2004): 68–73, http://www.airforcemag.com/MagazineArchive/Documents/2004/April%202004/0404japan.pdf.
86. "B-29 Combat Mission Logs, 1945, of William C. Atkinson, Radar Navigator," https://atkinsopht.wordpress.com/2017/11/19/b-29-combat-mission-logs-1945-of-wm-c-atkinson-radar-navigator.

Chapter 6

87. Spierling, oral history interview.
88. The information on targets comes from Bob Brown's missions list, courtesy of the Central Coast Veterans' Museum, and from the missions list kept by Sergeant John Ward, who flew with McChesney, courtesy of Michael McChesney.
89. "D-Day Leaders: Spaatz," accessed July 10, 2017, http://www.military.com/Content/MoreContent1/?file=dday_leaders7.
90. Spierling, oral history interview.
91. Schuchardt, oral history interview.
92. Albert Lee Findley Jr., interview, Central Coast Veterans' Museum, July 7, 2017.
93. "County Men in the Fight: Jess M. McChesney," *San Luis Obispo Telegram-Tribune*, May 17, 1945, p. 1.
94. Leroy McChesney III, interview with the author, Arroyo Grande, California, May 9, 2017.
95. David Middlecamp, "Arroyo Grande Veteran Survived Three Plane Crashes in World War II," *San Luis Obispo Tribune*, May 27, 2016, http://www.sanluisobispo.com/news/local/news-columns-blogs/photos-from-the-vault/article80444052.html.

96. McManus, *Deadly Sky*, 269.
97. Victor Gregg, "I Survived the Bombing of Dresden and Continue to Believe It Was a War Crime," *Guardian*, February 15, 2013, https://www.theguardian.com/commentisfree/2013/feb/15/bombing-dresden-war-crime.
98. Miller, *Masters of the Air*, 305–6.
99. Jeffrey Meyers, "The Death of Randall Jarrell," *VQR: A National Journal of Literature and Discussion* (Summer 1982), http://www.vqronline.org/essay/death-randall-jarrell.

Chapter 7

100. Findley, oral history interview.
101. Dwight, oral history interview.
102. Miller, *Masters of the Air*, 387–88.
103. "Stalag XIII-D," accessed July 17, 2017, http://wwii-pow-camps.mooseroots.com/l/264/Stalag-13D-Oflag-73.
104. Dwight, oral history interview.
105. Dickson, oral history interview.
106. Gibson, oral history interview.

Chapter 8

107. "Messerschmitt Bf 110 (Me-F110)," Acepilots, accessed July 18, 2017, http://acepilots.com/german/bf110.html.
108. McManus, *Deadly Sky*, 51.
109. Jim Gregory, *World War II Arroyo Grande* (Charleston, SC: The History Press, 2016), 102.
110. David Middlecamp, "Photos from the Vault: P-38 training crash in Santa Maria, World War II Week by Week," *San Luis Obispo Tribune*, accessed July 18, 2017, http://www.sanluisobispo.com/news/local/news-columns-blogs/photos-from-the-vault/article39511437.html.
111. "Chester Eckermann," oral history interview by Joanne Cargill, Central Coast Veterans' Museum, April 26, 2007, Chester Earl Eckermann Collection (AFC/2001/001/49482), Veterans History Project, American Folklife Center, Library of Congress.
112. Stout, *Vanished Hero*, xvi.

113. Dr. Henry Goodall, "Joe Griffin: Memoirs of Summer 1944: 367th USAF Fighter Group," Friends of the New Forest Airfields, March 21, 2016, https://fonfasite.wordpress.com/2016/03/21/joe-griffin-memoirs-of-summer-1944-367-fg.
114. "France—Crashes 39-45: Crash du P-38 Lightning type J-15-LO s/n 42-104212," accessed July 18, 2017, http://francecrashes39-45.net/page_fiche_av.php?id=6175.
115. "Quesada, Elwood Richard, Aviation Pioneer," National Aviation Hall of Fame, accessed July 19, 2017, http://www.nationalaviation.org/our-enshrinees/quesada-elwood-richard.
116. Michael D. Hull, "Embattled Skies: Air Power at the Battle of the Bulge," Warfare History Network, January 7, 2016, http://warfarehistorynetwork.com/daily/wwii/embattled-skies-air-power-at-the-battle-of-the-bulge.
117. "Heinkel He 162 Jet Fighter Test Pilot," PeninsulaSrVideos, December 28, 2012, https://www.youtube.com/watch?v=xmJqjx9VVKM.
118. "William K. Pope," oral history interview by Joanne Cargill, Central Coast Veterans' Museum, December 3, 2009, William Pope Collection (AFC/2001/001/71853), Veterans History Project, American Folklife Center, Library of Congress.
119. Stout, *Vanished Hero*, 83.
120. "Statistical Record, 55th Fighter Group," accessed July 19, 2017, http://www.55th.org.
121. Stout, *Vanished Hero*, xi–xiii.
122. David Middlecamp, "Remembering Elwyn Righetti on Memorial Day," *San Luis Obispo Tribune*, May 21, 2015, http://www.sanluisobispo.com/news/local/news-columns-blogs/photos-from-the-vault/article39533085.html.

Epilogue

123. David D. Floyd, former Cal Poly architecture student, personal communication, July 10, 2017.
124. Stuart, oral history interview.
125. Record of KIA status for Lieutenant Raymond Ranger, National Archives, accessed July 20, 2017, https://www.fold3.com/image/29032675.
126. Incident report, Hickam Field, 21 April 1945, accessed July 20, 2017, https://www.fold3.com/image/295871536.

INDEX

A

Ah Louis Store 18
American cemetery at Colleville-sur-Mer 113
anoxia 52, 72
"area bombing" 65
army food 62
Army General Classification Test 30
Arnold, General Harold "Hap" 30, 35, 81, 82, 88
Arroyo Grande 20, 49, 52, 62, 65, 66, 69, 70, 72, 87, 92
AT-6 "Texans" 38, 40, 41
Atascadero 111, 115
Avenger Field 38, 40

B

B-17 Flying Fortress 9, 12, 13, 14, 45, 48, 49, 51, 55, 68, 71, 88, 96, 106, 111, 116, 120
B-24 Liberator 25, 30, 34, 35, 42, 43, 45, 46, 48, 50, 51, 56, 71, 73, 77, 78, 88, 91, 93, 98, 101, 127

B-25 Mitchell 34, 73, 74, 76, 77
B-26 Marauder 53, 54, 57, 79, 114, 115
B-29 Superfortress 40, 45, 46, 78, 79, 80, 81, 82, 83, 107, 108, 115
 early problems 80
 failure of early raids on Japan 81
Ballagh, First Lieutenant Clarence Henry "Hank" 65, 66, 67
ball turret gunner 49, 50
Barter, Sylvia 40, 41, 42
Bastogne, Belgium 115
Battle of the Bulge 113
Bauer, Commander Harald "Hal" 115, 116, 117
Beachey, Hillery 17, 19, 20
Beachey, Lincoln 17, 18, 19, 20, 22, 23
Berkemeyer family 81
Berlin Airlift 58
"Big Week" 66, 69
"Black Monday" 68
blitzkrieg 87, 115
Blythe Army Airfield 40
"Blythe Spirit" 98
bombardier's duties 48

Index

Brown, Sergeant Robert 87
BT-9 Trainer 37

C

Cal Poly 22, 25, 26, 27, 31, 32, 33, 53, 54, 61, 73, 81, 87, 123
Cal Poly Naval Aviation program 31
Camp San Luis Obispo 26, 27, 29
chaff 51
Cherbourg, France 111
China-Burma-India (CBI) theater 78, 79
chin turret 50
Cholame 111
Civil Aeronautic Authority 27
civilian deaths 94
Clarkson, First Lieutenant William 86
Clothing, bomber crews 52
Cochrane, Jackie 38
copilot's duties 48
Corbett Canyon 23, 24, 91
Corsica 48
Costa, Frank 23
Covell, Second Lieutenant Nicholas 77, 78
Cowles, Sergeant Richard 49
Cramer, Captain Darrell 119
"Crazy Horse" (B-17) 66

D

daylight precision bombing 65
D-day 13, 59, 61, 111
Dickson, Captain Robert Abbey 45, 47, 48, 53, 56, 61, 102, 103, 104, 105, 106
diseases, South Pacific 74
Donalson, Second Lieutenant Randolph 34
Doolittle, General James 35, 68, 69, 70, 76, 97
Doolittle Raid 35
Dresden, Germany 55, 94, 95, 120
Dusseldorf, Germany 103
Dwight, First Lieutenant Robert Potter 10, 45, 47, 48, 55, 56, 98, 99, 100, 101, 102, 104, 105

E

Earhart, Amelia 21, 22, 23, 25
Eckermann, Colonel Chester 109
Eddy, Sergeant Charles 34
Eighth Air Force 49, 61, 64, 65, 68, 80, 82, 84, 87, 96
Engima 64
Engle, Second Lieutenant Melvin 44
Epernay, France 91

F

Fifteenth Air Force 48, 87, 90, 92
55th Fighter Group 117
Findley, Sergeant Albert Lee Jr. 10, 43, 44, 45, 51, 52, 62, 73, 91, 98, 99, 100, 101, 102
507th Fighter Group 123
flak 14, 25, 51, 52, 53, 54, 55, 57, 65, 66, 71, 75, 80, 83, 84, 87, 91, 93, 98, 103, 113
Fletcher, Eugene 36
flight engineer 49, 50, 62, 73, 84, 101
Focke-Wulf 190 14, 66, 93
40th Division 29
482nd Bomb Group 65, 66
405th Bomb Squadron 73
457th Bomb Group 84, 88
490th Bomb Group 116
468th Bomb Group 78
466th Bomb Group 44

INDEX

G

"Georgia Peach" (B-17) 84, 85, 86
Gibson, Sergeant John Sanderson 10, 78, 79, 80, 107, 108
"GlenMont" 25, 26
"Gone with the Wind" (B-29) 79
"gooney birds" 123
"Great Escape" 106
Grenier Field 47
Griffin, First Lieutenant Joe (367th FG) 111
Grover, First Lieutenant Roy Lee 73, 75, 76, 77
Gunn, Lieutenant Colonel "Pappy" 77

H

Hagerman, First Lieutenant Elmer 37
Hall, Technical Sergeant Henry 33, 54, 55, 68
Hancock, Allan 34
Hancock Field 31, 34, 35, 76
Harris, Sir Arthur "Bomber" 94
He-162 115, 116
Heller, Joseph 55
Heller, Sergeant Peder 92
Hickam Field 127
Hiroshima 123
Hogan, Frances Marie (Ballagh) 66
Holcombe, First Lieutenant Ralph 66
Hollandia 78
Hoover family 25, 26, 81
Horner, Second Lieutenant Ed 65, 66, 68
Houffalize, Belgium 115

I

Ie Shima 75, 123, 125
Imperial Steel Works 79
incendiary bombs 82, 83, 94

interrogation of downed aviators 100
IP (Initial Point) 48
Iwo Jima 11, 81, 125

J

Japanese interrogation 107
Jarrell, Randall 97
Johnson, First Lieutenant Byron 43, 91, 100
Jones, First Lieutenant Richard Vane 10, 53, 54, 57, 61

K

"Katydid" (P-51) 28, 120
Keegan, John 58
kempeitai (Japanese military police) 107
Kennedy, Robert E. 31
Kharagpur, India 78
"kriegs" 105

L

Lady Moe (96th BG mascot) 70, 71, 72
Laird, Sergeant Donal 50
Lamb, First Lieutenant Jim 70
Langston, Second Lieutenant Jack 111, 112, 113
Lauppe, Ed 26
Lee, Second Lieutenant Ted 78
LeMay, General Curtis 82
Lindbergh, Charles 25, 34
Lorient 11, 13, 15, 64, 65
Luftwaffe 69, 88, 89, 95, 100, 103, 105, 108, 109, 110, 115, 118

M

Madonna, Alex 15, 81
Magdeburg, Germany 98
Marianas Islands 80
Mauldin, Bill 62

INDEX

McChesney, Captain Jess Milo 23, 25, 30, 59, 87, 91, 92
McChesney, Leroy Jr. 23, 24
McFadden, Yancey 18
McManus, John 36, 94
McPhee, Julian 31
Me-262 115
"Memphis Belle" 46
Messerschmitt Bf 110 109
Messerschmitt Me-109 110, 119
Mira Loma Flight Academy 36
Morro Bay 11, 15, 33, 45, 64, 102
Mrenak, First Lieutenant Frank 125, 126, 127

N

Nagasaki 124, 125
navigator's duties 48
New Guinea 16, 73, 74, 75, 76, 77
Nilsson, Captain Jack 80, 81, 82, 83
91st Bomb Group 47, 55, 61, 68
97th Bomb Group 89
96th Bomb Group 69, 70, 87
96th Bomb Group 69, 71
90th Bomb Group 77
Norden bombsight 48, 65, 94
Norton, First Lieutenant Cornelius James 34

O

Oberursel, Germany 100
Oflag 79 101
oil campaign 88, 98, 110, 115
Okinawa 81, 125
100th Bomb Group 68
Operation Nordwind 113

P

P-38 Lightning 12, 47, 59, 92, 109, 110, 111, 112, 117
 weaknesses 109
P-39 Aircobra 34
P-47 Thunderbolt 75, 123
P-51 Mustang 8, 40, 86, 88, 117, 118, 119, 120
Pathfinders 65, 66
Pearson, First Lieutenant James 115
Peleliu 78
phase training 45
pilot's duties 48
Plocher, First Lieutenant Martin E. 11, 15
Ploesti 87, 88, 91
Pope, Colonel William K. 117, 118
PT-13 Kaydet 34
pubs 62
Punches, Second Lieutenant Joel 68

Q

Queen Mary 47, 48, 61
Quesada, General Pete 113
Quimby, Harriet 20, 21, 22
 death, 1912 22

R

Rabaul 76
radio operator 50
RAF Alconbury 65, 66
RAF Bassingbourn 61
RAF Snetterton Heath 61, 70, 71, 72, 87
Ranger, First Lieutenant Ray 125, 126, 127
Riesa, Germany 121
Righetti, Lieutenant Colonel Elwyn 27, 30, 36, 111, 119, 120
 shot down 121

INDEX

Roberts, Carol 93
Rogers, Colonel Art 77
Rooney, Dorothy May Moulton 37, 38, 40, 42

S

San Luis Obispo 15, 16, 17, 18, 19, 22, 23, 25, 27, 29, 34, 45, 55, 77, 80, 81, 87, 93, 101, 111, 119
San Pancrazio, Italy 91
Schuchardt, Major Harold 10, 47, 48, 89, 90, 91, 121
Shikoku 123
Singapore 80, 107, 108
skip-bombing 76
Southern Cross 35
Spaatz, General Carl "Tooey" 87, 88, 98, 110
"special relationships" 62
Spierling, Technical Sergeant Albert 10, 52, 62, 84, 85, 86, 87, 88, 89, 96
Stalag Luft I 105
Stalag Luft I. 105
Stalag Luft III 106
Stalag VII 102
Stalag XIII-D 100, 101
Stearman Kaydets 32
Stewart, Major James 46
Stine, Betty Pauline 40
St. Lo, France 96
Story, Major General Walter 26
strafing runs, danger of 111
Straits of Malacca 80
Stuart, First Lieutenant John Sim 10, 73, 74, 123, 124, 125, 126, 127
Stuart, Mary 126

T

Templeton 115
terrorflieger 103
Thomson, Earl 25, 28, 81
381st Bomb Group 61
390th Bomb Group 49
367th Fighter Group 111
303rd Bomb Group 11, 16, 46, 48, 64
"Tokyo Sleeper" (B-25) 73, 76, 77
Tompkins-Silver, Gertrude "Tommy" 40
Tyler, Second Lieutenant Clair Abbott 11, 12, 14, 15, 16, 46, 64, 66, 81

U

U-boats 58, 64
Unbroken 35
USS *Arizona* 29
USS *Missouri* (and Japan's surrender) 125

V

V-1 55, 115
Vonnegut, Kurt 94

W

waist gunner 53
Walker, General Kenneth 76
WASP 38, 39, 40
"Wheel and Deal" 102
Whitlock, Second Lieutenant Daniel Elliott 69, 70, 71, 72
Willis, Air Cadet Frederick George 34
Wyler, Major William 46

Z

Zamperini, Louis 35

ABOUT THE AUTHOR

This is longtime Arroyo Grande resident Jim Gregory's fourth book on local history, following *World War II Arroyo Grande*, *Patriot Graves: Discovering a California Town's Civil War Heritage* and *San Luis Obispo County Outlaws: Desperados, Vigilantes and Bootleggers*. Gregory attended local schools, including the two-room Branch School in the Upper Arroyo Grande Valley; Cuesta College, the University of Missouri, where he received a degree in history; and Cal Poly, where he received his teaching credential. He taught for thirty years at Mission Prep in San Luis Obispo and at Arroyo Grande High School. He was Lucia Mar's Teacher of the Year in 2010–11 and began writing on his retirement in 2015. Gregory is married to Elizabeth, campus minister and teacher at St. Joseph High School in Santa Maria, and the father of sons John and Thomas.